# THE LITTLE BOOK OF

# CARTOONING & ILLUSTRATION

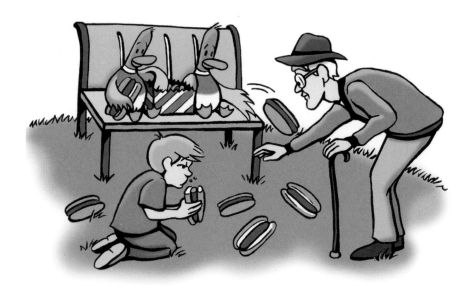

## MORE THAN 50 TIPS AND TECHNIQUES
### FOR DRAWING CHARACTERS, ANIMALS, AND EXPRESSIONS

Brimming with creative inspiration, how-to projects, and useful information to enrich your everyday life, Quarto Knows is a favorite destination for those pursuing their interests and passions. Visit our site and dig deeper with our books into your area of interest: Quarto Creates, Quarto Cooks, Quarto Homes, Quarto Lives, Quarto Drives, Quarto Explores, Quarto Gifts, or Quarto Kids.

© 2018 Quarto Publishing Group USA Inc.

Artwork on pages 5, 14-20, 22-26, 28-29, 33 (watercolor), 44-51, 54-77, 103-108, 110-116 © Maury Aaseng; pages 6-7 © Shutterstock; pages 8, 10-13, 21, 27, 32-39, 83-87 © Joe Oesterle; pages 88-99 © Clay Butler; pages 119-127 © Dan D'Addario. Cover artwork © Maury Aaseng, Joe Oesterle, and Alex Hallatt.

First published in 2018 by Walter Foster Publishing, an imprint of The Quarto Group. 26391 Crown Valley Parkway, Suite 220, Mission Viejo, CA 92691, USA. **T** (949) 380-7510 **F** (949) 380-7575 **www.QuartoKnows.com**

Walter Foster Publishing titles are also available at discount for retail, wholesale, promotional, and bulk purchase. For details, contact the Special Sales Manager by email at specialsales@quarto.com or by mail at The Quarto Group, Attn: Special Sales Manager, 100 Cummings Center, Suite 265D, Beverly, MA 01915, USA.

ISBN: 978-1-63322-620-3

Digital edition published in 2018
eISBN: 978-1-63322-621-0

Printed in China
10 9 8 7 6

# TABLE OF CONTENTS

# INTRODUCTION

Cartooning is such a freeing form of art. With a stroke of a pencil, you can draw without being shackled to realistic details; create situations that could never happen; and put your sense of humor on display, no matter how zany! This book provides tips and suggestions to hone your cartoonist eye and demonstrates techniques to create your own light-hearted creations. Step-by-step projects introduce basic character design and explain the process of bringing an entire cartoon to completion. It's a big world out there, so enjoy making fun of it all, with a pencil in hand and this book as a guide.

# TOOLS & MATERIALS

There is a wide range of tools and materials available for cartooning and illustration. With so many options, it's a good idea to explore and experiment to discover which you like the best! Below are some good choices to start with.

## PAPER

Sketch pads and inexpensive printer paper are great for sketching and working out your ideas. Tracing paper can be useful in creating a clean version of a sketch using a light box. Card stock is sturdier than printer paper, which makes it ideal for heavy-duty artwork. You may also want to have illustration board on hand.

## PENCILS

Pencil lead, or graphite, varies in darkness and hardness. Pencils with a number and an H have harder graphite, which marks paper more lightly. Pencils with a number and a B have softer graphite, which makes darker marks. A good pencil for sketching is an H or HB, but you can also use a regular No.2 pencil.

## ERASERS

Vinyl and kneaded erasers are both good to have on hand. A vinyl eraser is white and rubbery and is gentler on paper than a pink eraser. A kneaded eraser is like putty. It can be molded into shapes to erase small areas. You can also lift graphite off paper to lighten artwork.

## INDIA INK

India ink is black ink made of carbon. It is a traditional inking material for comic book artists.

## QUILL OR DIP PEN

Quill and dip pens provide some flexibility with line when inking. You can purchase different sizes of nibs. Be careful when inking with these tools. They often leave lines that stay wet for several minutes. Make sure you allow for plenty of drying time!

## MARKERS

Most cartoon and illustration work is colored digitally today, but if you'd rather use traditional materials, art markers are perfect for adding bold, vibrant color to your artwork.

## FELT-TIP PEN OR FINE LINE MARKER

Use a black felt-tip (or fiber-tip) pen or fine-line marker to tighten your lines and ink your final pencil illustrations.

## TEMPLATES & RULER

You can find circle, ellipse, and curve templates at any art supply store. These templates are perfect for making dialog balloons. You'll also find it handy to keep a ruler nearby for lettering your illustrations.

## DIGITAL TOOLS

The majority of professional cartoon and illustration work is finished digitally, but don't worry if you're not set up for this. You can still create beautiful full-color illustrations using markers, colored pencils, or even paint. If you want to give digital illustration a try, you'll need your computer, a scanner, and image editing software such as Adobe Photoshop®.

# GETTING STARTED

## STUDY THE ACTING GREATS

Just as it's important to study the style of cartoons you've seen on T.V., in movies, and in books, it is helpful to research some of Hollywood's great comic actors beginning with the Silent Era. These actors had to show what they were feeling without using words, so they became experts at acting out each emotion—primarily by using facial expressions. Start with the masters, including Charlie Chaplin, Laurel and Hardy, and Harold Lloyd. These actors communicated their feelings in a broad way, and that's exactly the kind of emphasis on exaggeration you'll need to implement to portray the feelings of your cartoon characters on paper.

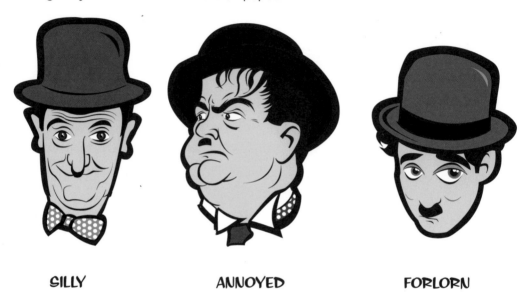

SILLY                    ANNOYED                    FORLORN

### KEEP A SKETCHBOOK

Every cartoonist should keep a sketchbook. Draw daily! There will always be something else you need to do, but you have to set aside time for cartooning. And you can *always* find the time.

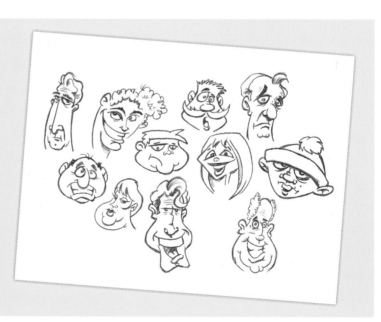

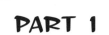

PART 1

# LEARNING THE RULES

**IF YOU WANT TO BREAK THE RULES,** you must first know the rules. Otherwise how would you know you're breaking them? That means you'll need to learn to draw a traditional face on an oval-shaped head—because that's what the rules would have you do.

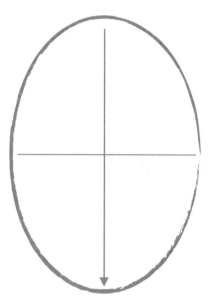

**STEP 1** Draw a midline from top to bottom, dividing the faces into halves. Next draw a horizontal center line from left to right.

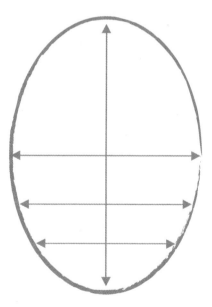

**STEP 2** Now you will divide the lower half of the oval into thirds.

**STEP 3** As you can see, these guidelines show you where to place the eyes, nose, and mouth.

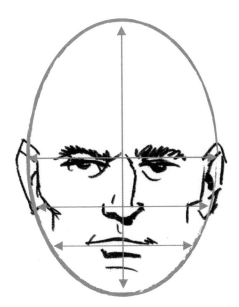

**STEP 4** Sketch in the eyes, nose, mouth, and ears.

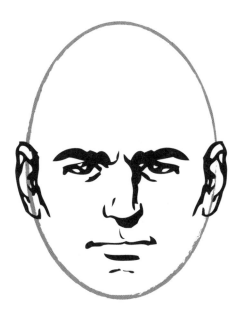

**STEP 5** Now darken and refine your facial features, and you've got yourself a very traditional drawing of a head.

# YOUR TURN!

Use this template to practice drawing in facial features.

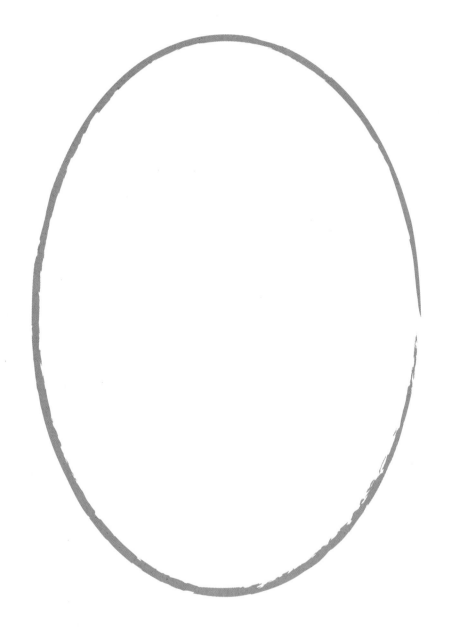

# BREAKING THE RULES...
# LET THE FUN BEGIN!

**SOMETIMES A REGULAR "FOLLOW-THE-RULES"** face is okay, but you didn't set out on this journey to be just okay. You want to be exceptional and stand out from the crowd! You want noses to be longer than cucumbers, mouths to be smaller than coins, and eyes to be different sizes. In the examples below, you will still use the traditional oval head shape, but you will place the features in nontraditional places. Welcome to real cartooning!

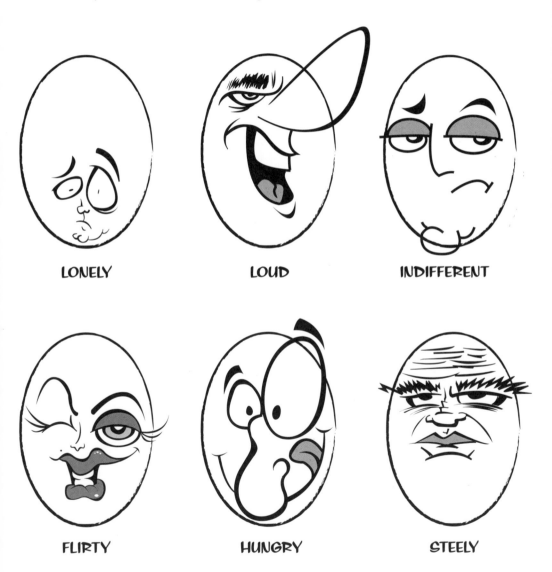

LONELY                  LOUD                  INDIFFERENT

FLIRTY                  HUNGRY                  STEELY

# HEADS

Much of a character's personality, attitude, and feeling is captured by a simple shape. Try drawing a shape on your paper, and then see what kind of character jumps out. Try as many shapes as you can. Take a look at the many heads on pages 14–17 and note how the shapes lend themselves to certain expressions. Then use the templates on pages 18–19 to practice creating your own.

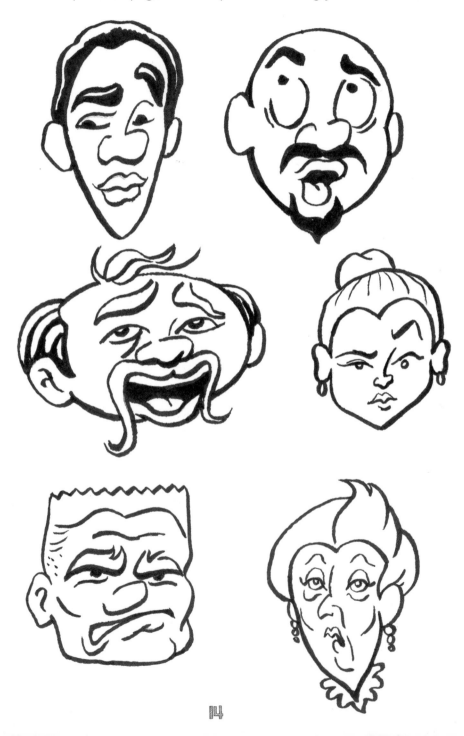

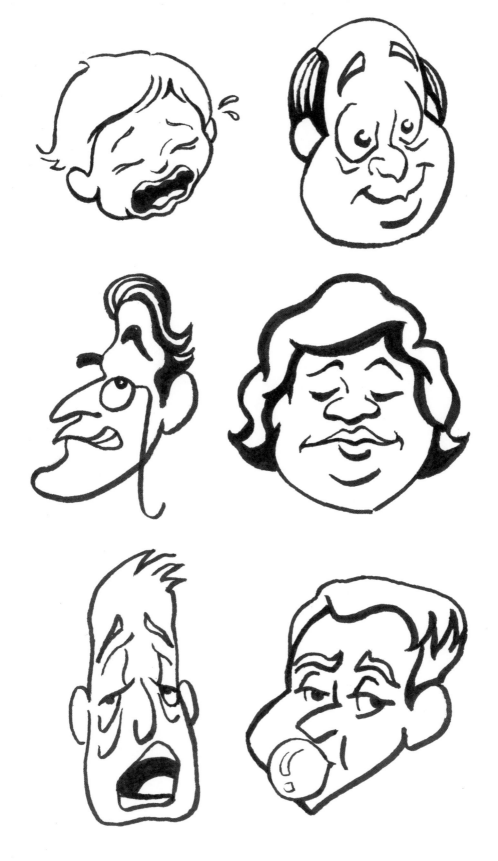

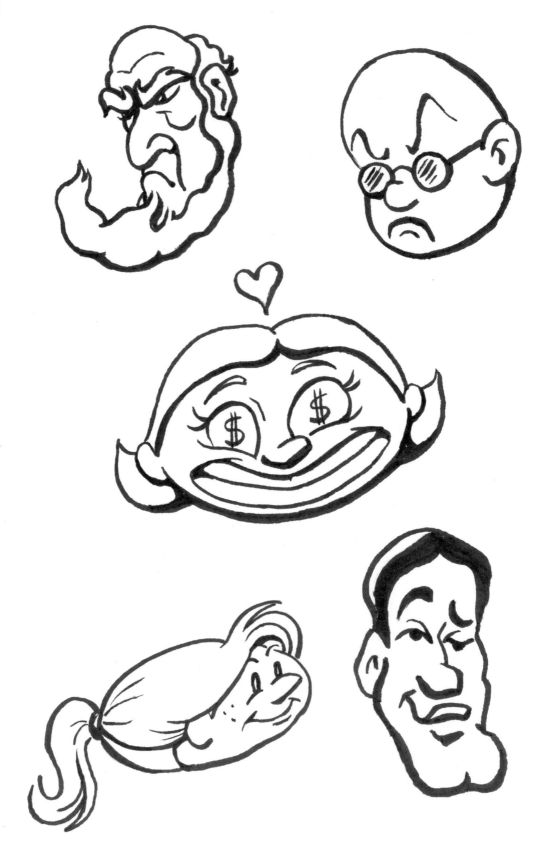

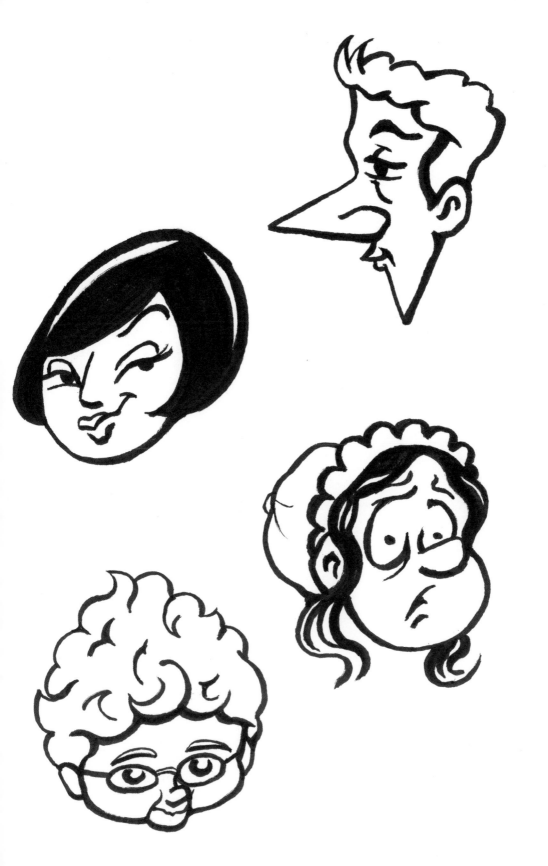

# PRACTICE HERE

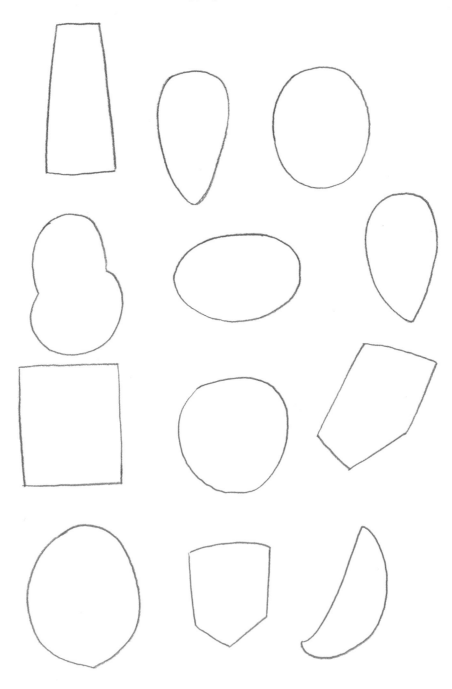

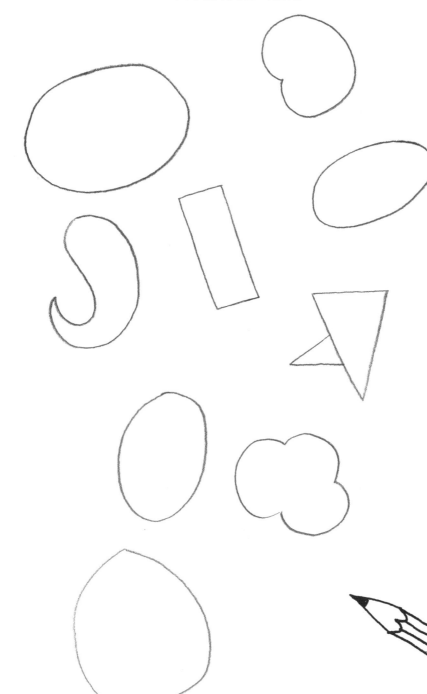

# HEAD POSITION

In this illustration, you can see how rotating the head infuses energy into the character. He can be happy with one person and furious with another. His head can be tipped back with laughter, pointed downward as he grumbles, or tilted away while he sleeps. Recognizable features are built into his design, so that no matter which direction he faces, he is recognizable as the same character.

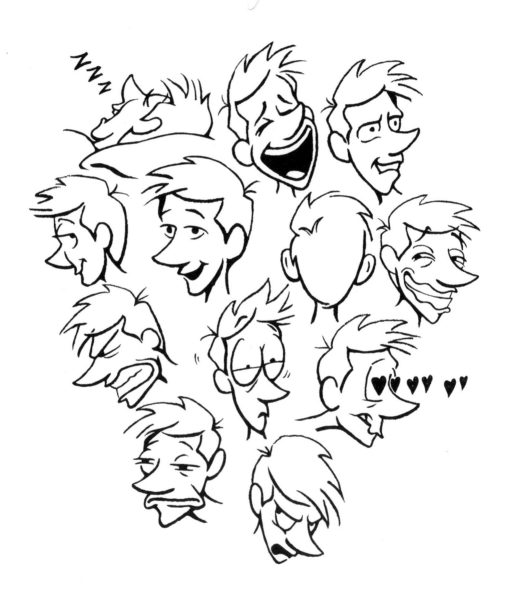

# THE SQUASH & STRETCH PRINCIPLE

Early animators created the "Squash & Stretch Principle."
These pioneer cartoonists realized the importance of exaggeration
when conveying both motion and emotion. Notice how much emotion
you're able to demonstrate by simply "rubberizing" a character's head.

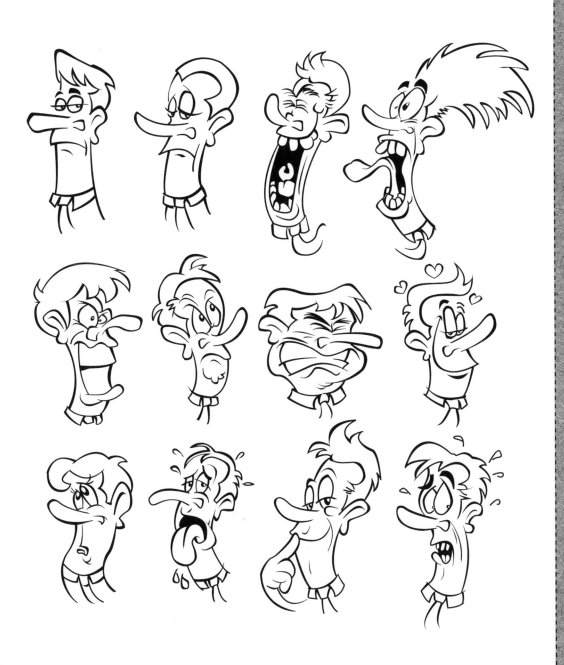

# BASIC EXPRESSIONS

There are a variety of expressions you can make by just drawing a few simple lines and shapes!

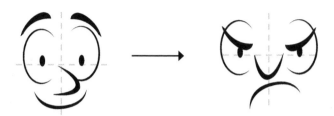

## HAPPY
Make a smiling face, with raised eyebrows and an upturned mouth.

## GRUMPY
Use the same shapes, but flip the mouth and eyebrows upside down. Point the nose down, to reinforce the frowning look.

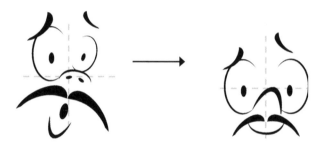

## SCARED
Alter the size and scale of some shapes. Switch the shapes of the nose and mouth. Duplicate the shapes of the pupils for the nostrils.

## INSECURE
Use the same shapes, but duplicate some and change the size and scale of others to create facial hair and a new expression.

## DEFINING FEATURES
Practice drawing different expressions for the same character to develop the range and depth of her emotions. Choose distinguishing characteristics that stay the same to keep the character recognizable.

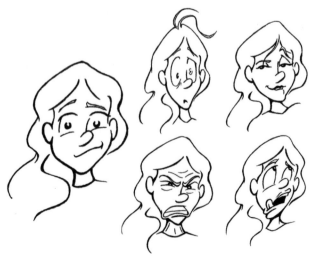

# EYES

The size of the whites of the eyes, pupils, and eyelids
can all be modified for different expressions.

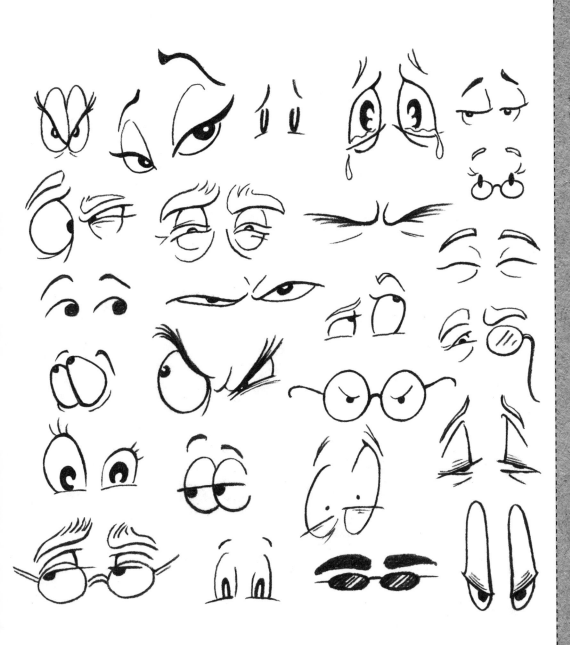

# MOUTHS

There are lots of ways to draw mouths. Wobbly lines suggest embarrassment.
Big white areas of teeth could suggest a huge grin or frustration,
depending on whether the mouth is turned up or down.

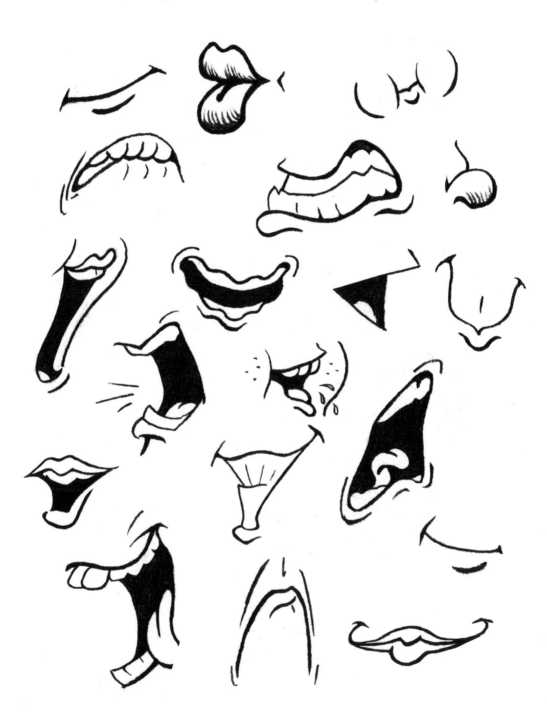

# NOSES

Noses aren't particularly key in giving away a character's emotion. Since there is a wide variety of how "cartoony" or "realistic" a character might look, a nose can take a variety of shapes. In a basic cartoon, a simple pointed line or rounded swoop is enough to suggest the character's nose. For a cartoon with a little more detail, some suggestion of the nostrils or the bridge of the nose will bring more definition to the face. Play with scale and size.

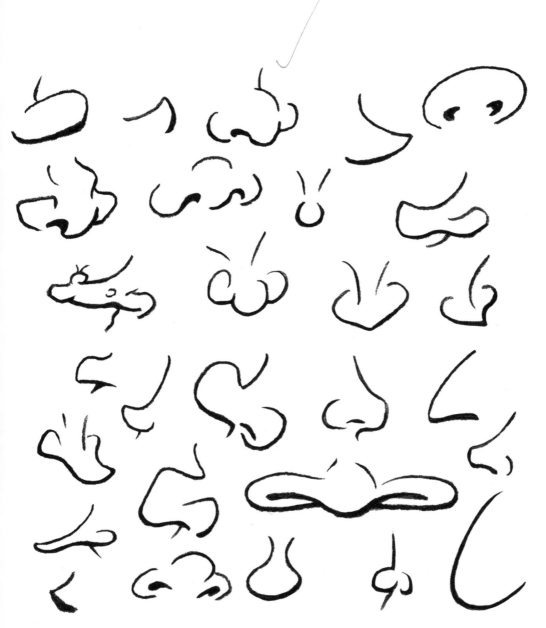

# EARS

Like noses, ears are not the most important aspect of facial expression, but they are a good opportunity to further develop a character's look. Also similar to noses, there are a variety of shapes to pick from.

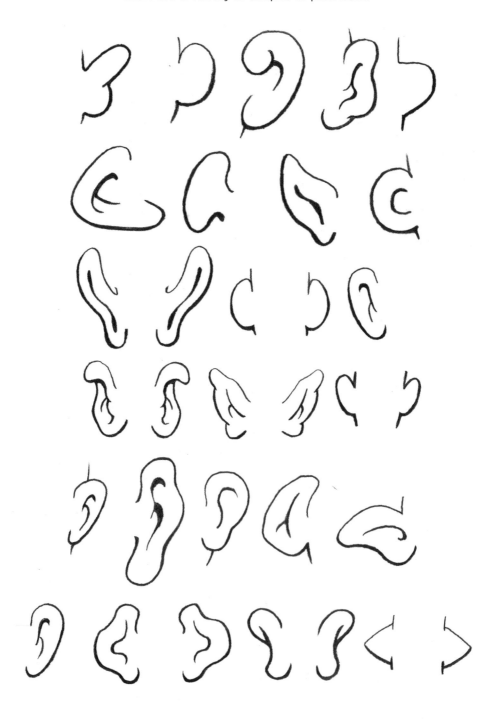

# COMBINING EMOTIONS

## PUZZLED & THINKING

A thinking expression bears similarities to surprise. One eyebrow is arched and the mouth is small and closed, with a tiny frown. The eyes are open wide, but they seem to be looking for an answer.

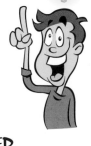

## INSPIRED

To illustrate inspiration, start with a happy expression dialed back a bit. Both eyebrows are arched, the smile is big, and the eyes are wide open. A raised index finger and a light bulb over the head help convey that he has a brilliant idea.

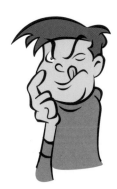

## SKEPTICAL

Skepticism is portrayed by combining anger and disgust. The eyebrows furrow, one eye squints, and the mouth contorts.

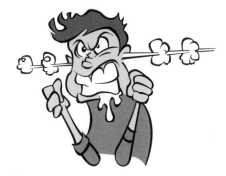

## ENRAGED

These are elements of anger amped up a few notches. You can help illustrate this by drawing steam coming out of the ears and drool oozing from behind clenched teeth.

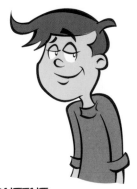

## CONTENT

Contentment is a scaled-down happy expression. Eyebrows are arched, eyelids are half closed, and a half smile begins to emerge.

## EMBARRASSED

Embarrassment is a combination of happy and sad expressions. The eyebrows bend upward, and the eyes are wide but sheepish. Shrugged shoulders, a crooked smile, and a faint blush on the face sell this expression.

# HEADS & FACES STEP BY STEP

A simple shape is the blueprint for a cartoon's head and body and can suggest a character's attitude and feeling. Try as many shapes as you can; you may be surprised at the variety of characters that live in your head!

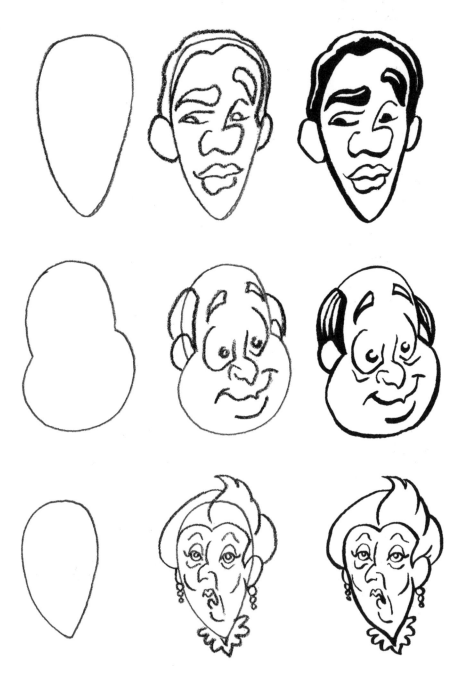

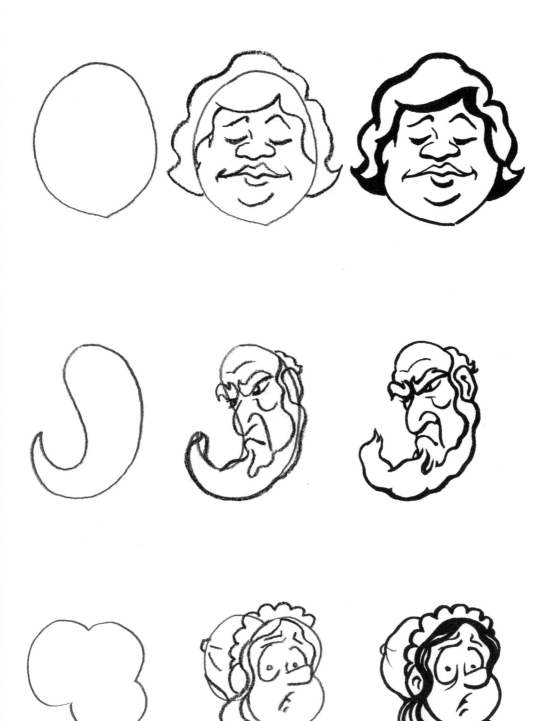

# PRACTICE HERE

# PRACTICE HERE

# ADDING COLOR

Now use your favorite tools to give your cartoons some bold color.
Remember, in cartooning, you can be as fun and crazy as you like!

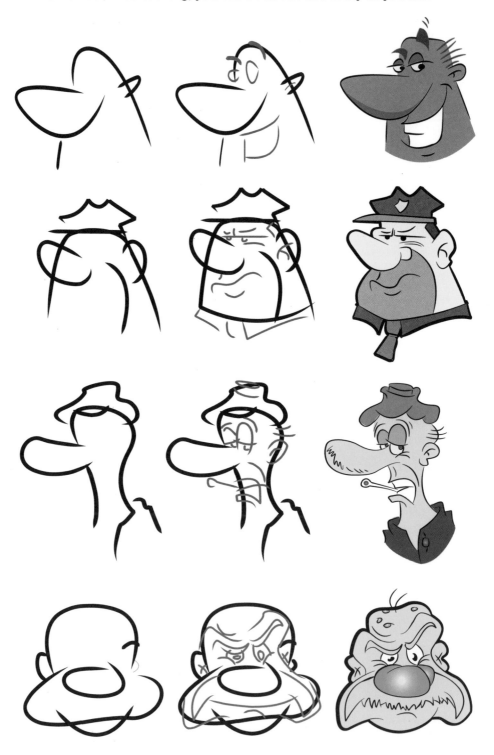

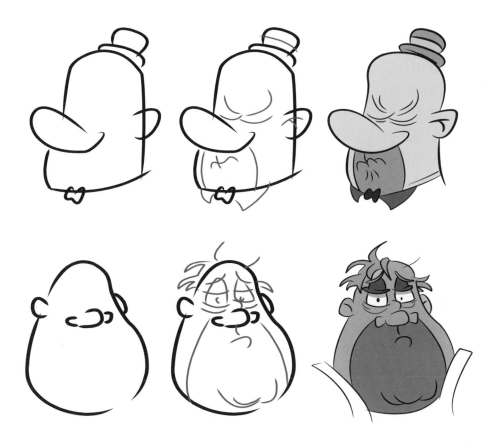

## WATERCOLOR

Want to mix things up? Try using a more traditional coloring method: watercolor. After choosing a general color scheme, mix up some different colors on your palette.

**Watercolor Tips:**
- For shadows, use less water in the pigment.
- For lighter shades, add more water to dilute the color.

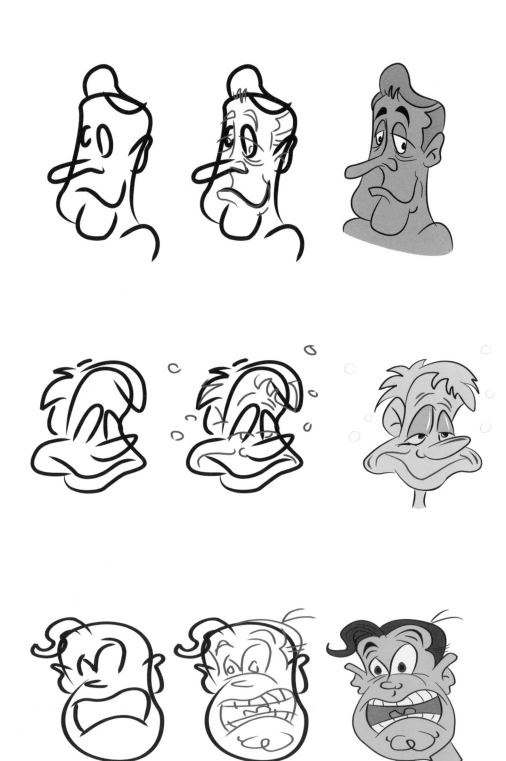

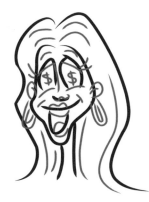
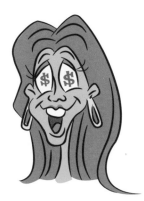

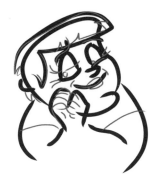
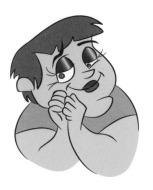

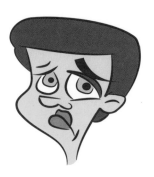

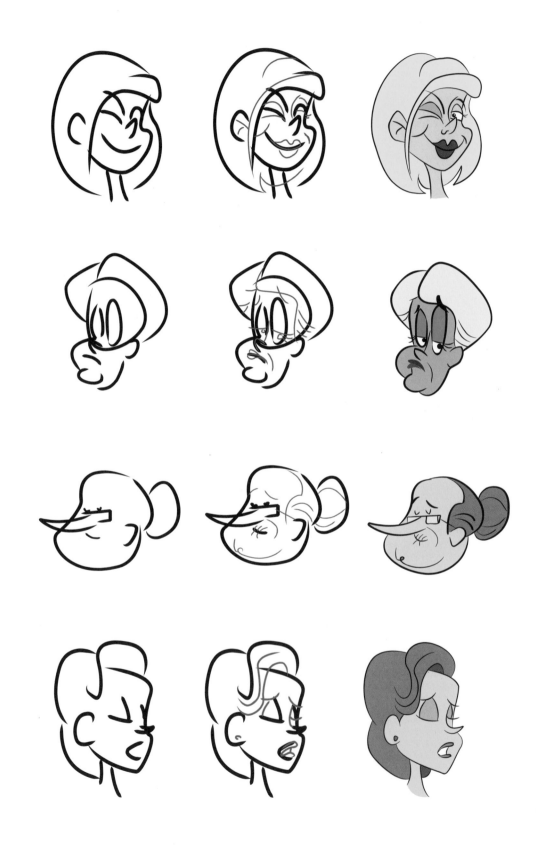

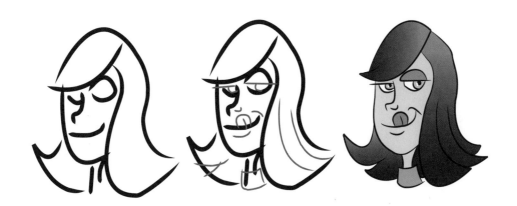

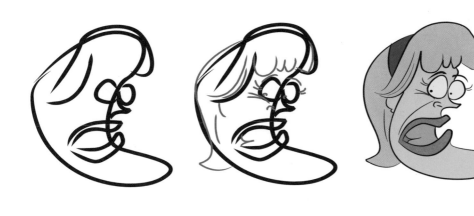

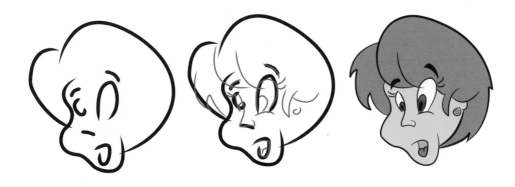

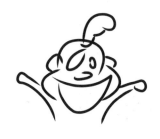
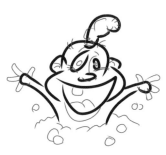
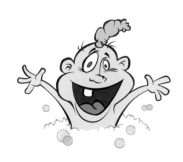

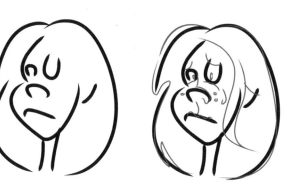
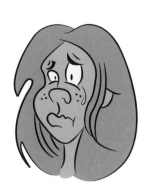

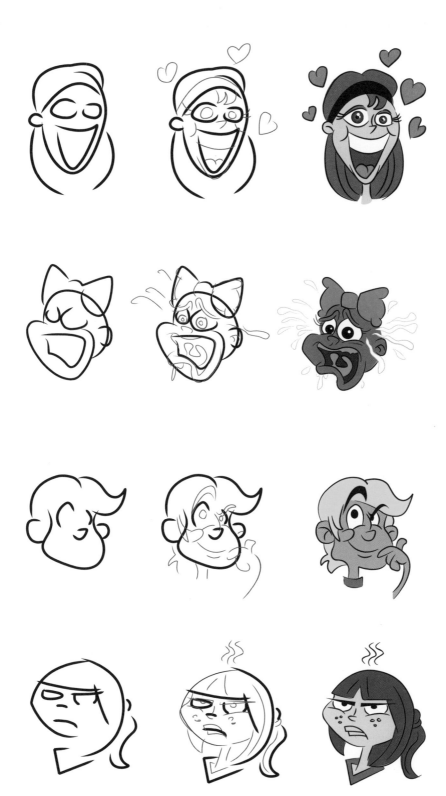

# PRACTICE HERE

# PRACTICE HERE

# PRACTICE HERE

# PRACTICE HERE

# BODIES

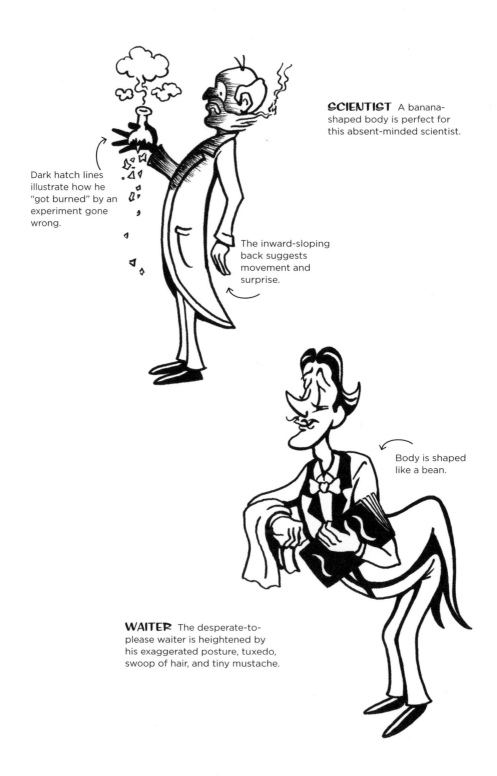

**SCIENTIST** A banana-shaped body is perfect for this absent-minded scientist.

Dark hatch lines illustrate how he "got burned" by an experiment gone wrong.

The inward-sloping back suggests movement and surprise.

Body is shaped like a bean.

**WAITER** The desperate-to-please waiter is heightened by his exaggerated posture, tuxedo, swoop of hair, and tiny mustache.

**TEEN** A chili pepper shape captures the posture of this young hipster.

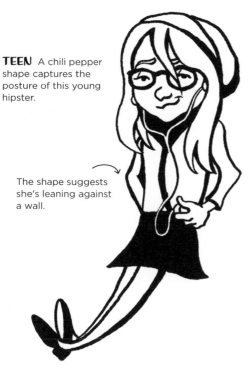

The shape suggests she's leaning against a wall.

**TODDLER** By adding short and stubby legs, outstretched hands, and tilting the face at an angle, you can easily create the look of a tiny kid dashing toward something (or someone) exciting.

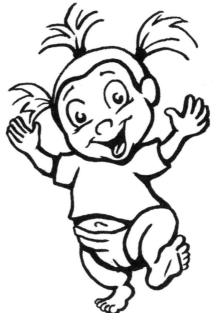

# HANDS

Below are three different styles of hands: a traditional cartoon hand (left);
a more human hand, albeit still quite cartoony (middle);
and a more realistic hand (right).

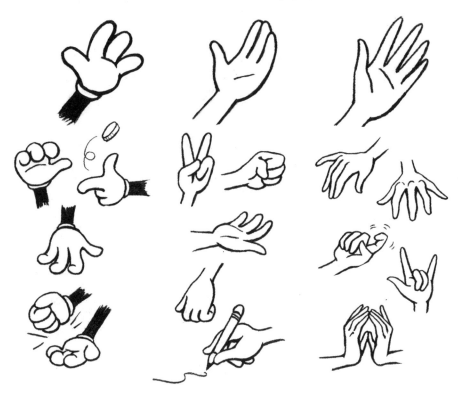

**The length and thickness of hands and fingers can vary depending
on if the hands belong to a child, a woman, or a man.**

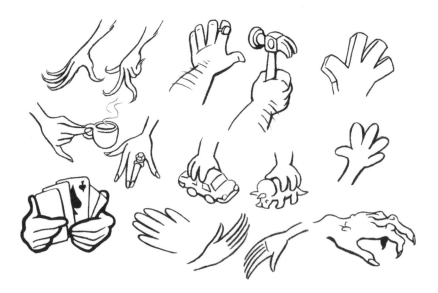

# FEET

Depending on the cartoon, feet can either be important features or just some ovals. By spending a little time and thought on the feet and footwear, you can add dimension and personality to your character.

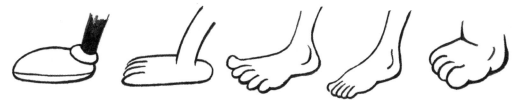

**Feet can be cartoony or realistic.**

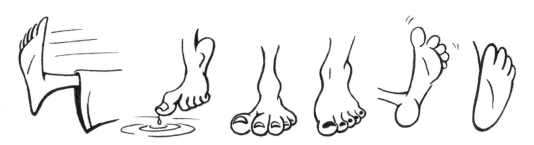

**Feet in different positions vary greatly depending on how accurately you choose to render them.**

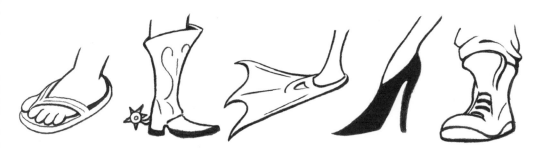

**You don't need to include a lot of detail to make footwear recognizable.**

# BODIES
# STEP BY STEP

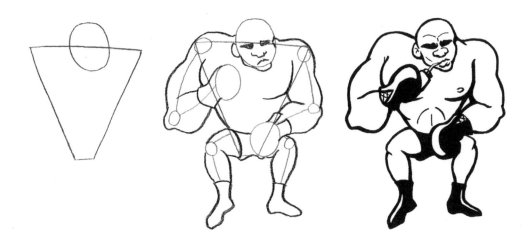

**BOXER** Begin with a circle intersecting an inverted trapezoid. Draw lines with circles marking the joints before adding the muscles. Add details to give this boxer character.

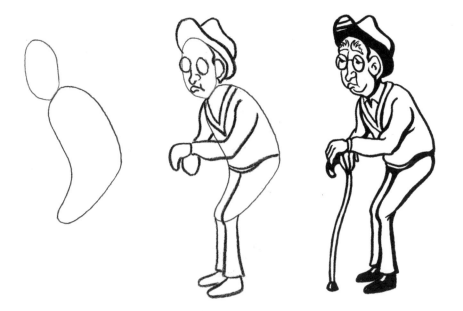

**ELDERLY MAN** A boomerang shape creates a sloping back, and a simple, elongated oval becomes the head. Sketch in limbs, hat, and facial features.

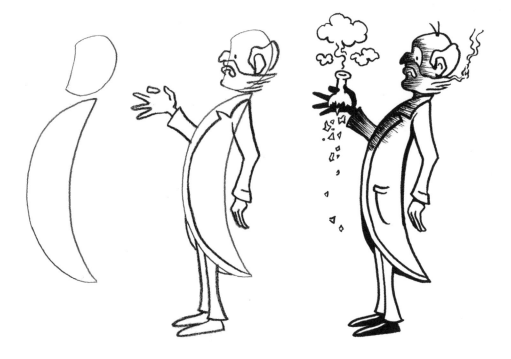

**SCIENTIST** Draw a banana-shaped body. Draw an oval with one flat side for the head, and add arms, legs, hands, and facial features, including a beard.

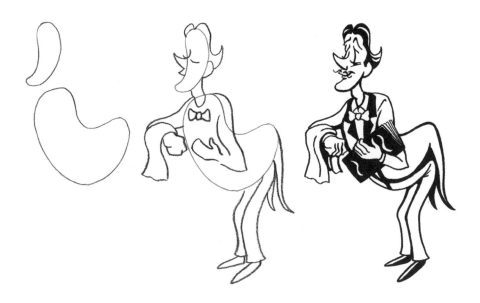

**WAITER** Start with two abstract, curved shapes floating near each other. Then connect the shapes with a noodlelike neck, legs, and arms.

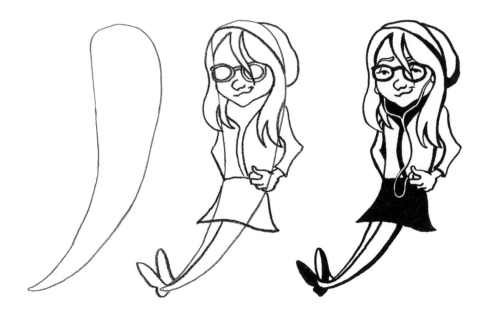

**TEEN** Draw a chili pepper shape for the body. Add an arm off to one side, and the tip of the chili becomes indistinct legs leaning on a wall. The top half of the chili morphs into the head.

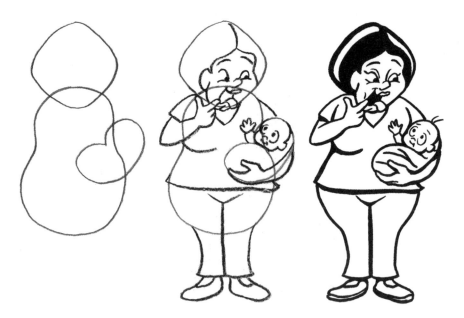

**MOM** Start with a peanut-shaped body and a rounded diamond for the head, adding a lima-bean-shaped baby body. Continue to add the details.

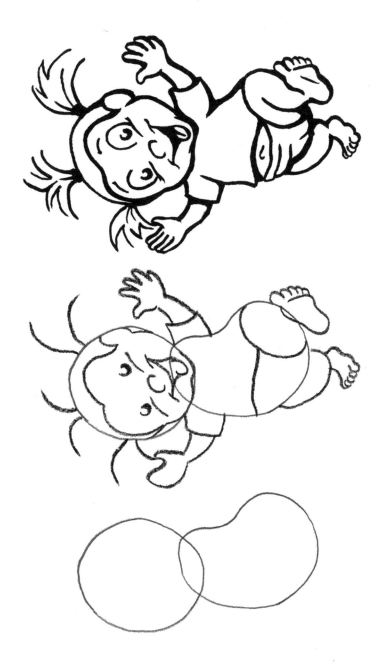

**TODDLER** A lima bean with a large circle on top creates the framework for a rambunctious toddler. Adding short and stubby legs, outstretched hands, and placing the face at a tilted angle creates the look of a tiny kid dashing towards something (or someone). Feature details, such as three fountainlike ponytails, an exposed belly button, and a visible tongue, help create the expression of uninhibited enthusiasm.

# PRACTICE HERE

# PRACTICE HERE

# FRIENDLY FELLOW

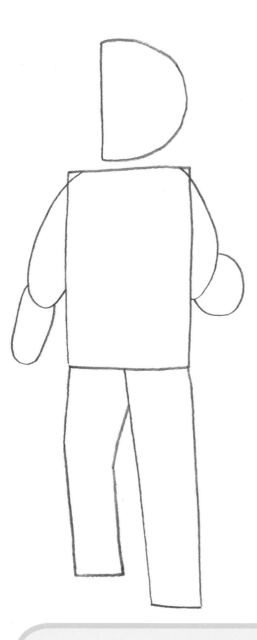

**STEP 1** Start by drawing a large rectangle for his torso and a big capital "D" to mark his head placement. Then draw elongated half-ovals for his sweater-wrapped arms and a bulbous shape at the end of each for hands. Draw straight lines for his legs.

ARTIST'S TIP

AS YOUR CHARACTER CONTINUES TO DEVELOP, ERASE THE OLD GUIDELINES SO THAT ONLY THE NEW ONES ARE VISIBLE. THIS HELPS KEEP YOUR DRAWING CRISP AND CLEAN.

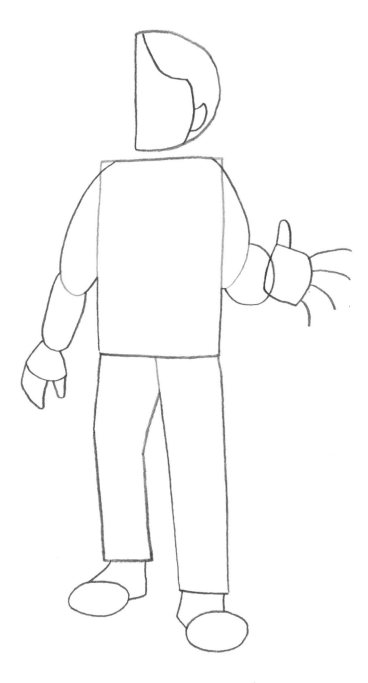

**STEP 2** Draw a curved, kinked line through the head to mark the hairline, and then draw the ear. Map the hands at the end of each arm, using simple shapes for the palms and thumbs. On the left arm, make a curved shape for the fingers; on the right hand, draw four curved lines for the fingers. Place two ovals below each pant leg to start the boots.

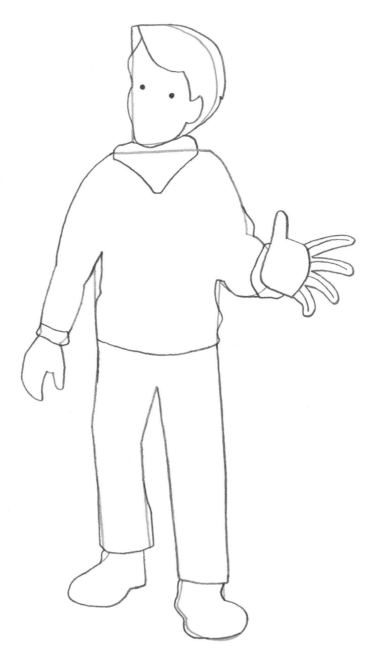

**STEP 3** Round out the sweater with more natural-looking folds, and soften the outlines of the pants and boots. Add curved lines on the left side of the face to create his profile. Extend the hairline on the back of the head, and add two dots to mark the eyes. Draw the cuffs and collar on the sweater. Draw contour lines around each finger line.

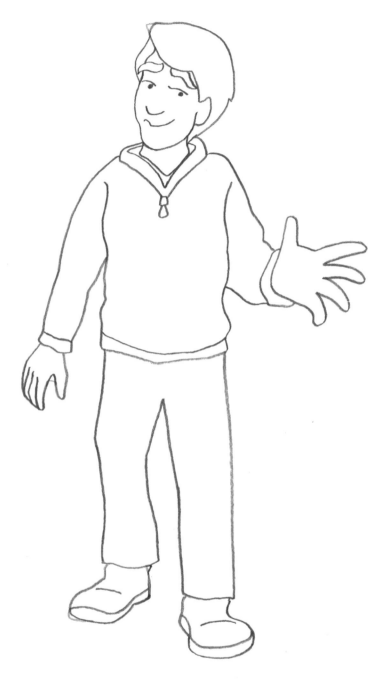

**STEP 4** Continue adding the details. Add another curved line to the hairline to frame the face. Then draw the eyebrows. Add two curves for his eyelids, one for the underside of his nose, and another for his bottom lip. Complete the clothing outline.

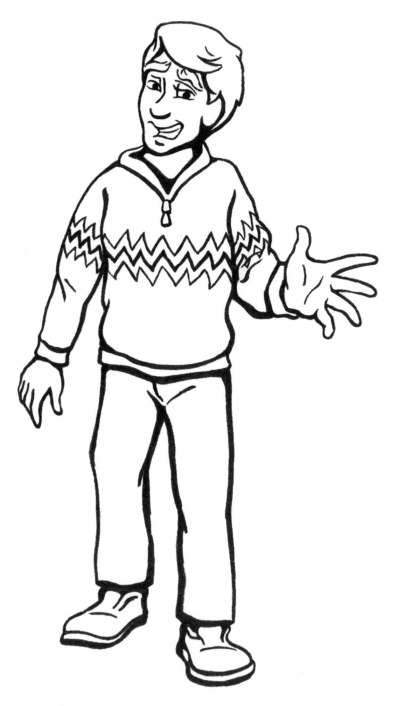

**STEP 5** Add the final details on his face, sweater, and boots. Then trace the pencil lines with a fine-tipped black marker.

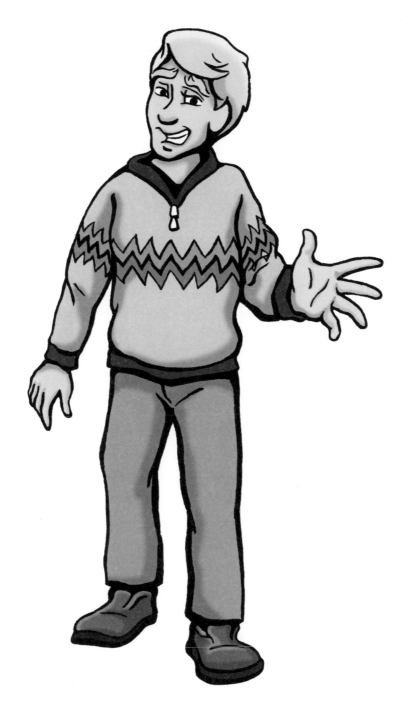

**STEP 6** Use pencils and markers to add color.

# LAKE SWIMMER

**STEP 1** Start with the most basic of shapes for the head and body.

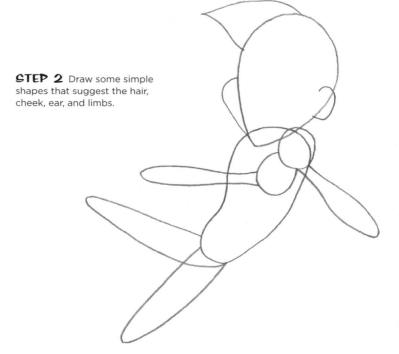

**STEP 2** Draw some simple shapes that suggest the hair, cheek, ear, and limbs.

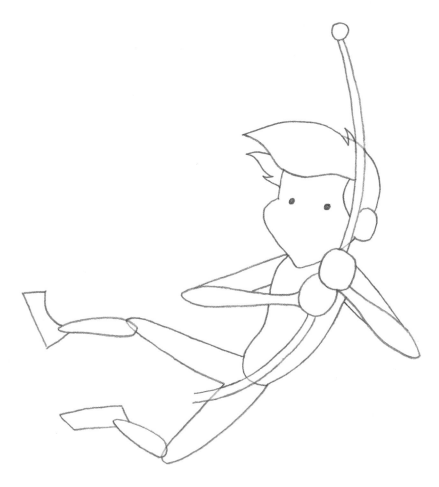

**STEP 3** Add another pair of stretched ovals and boxy shapes to finish marking the legs and feet. Add more detail to the hair. Then add the long curved lines that make up the rope, with the circle at the top marking the knot.

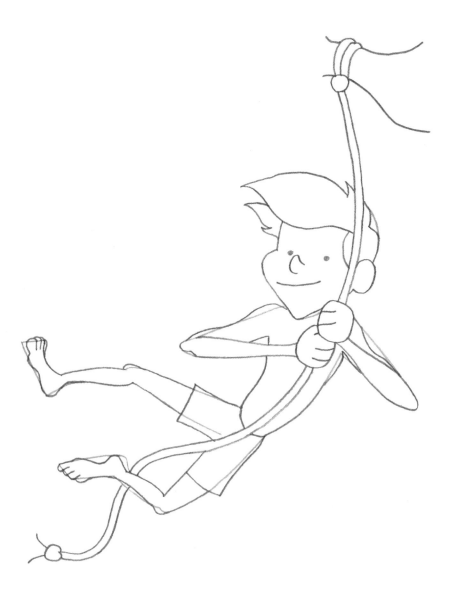

**STEP 4** Add natural-looking contour lines to the figure. Curved lines create a more natural look for the arms and legs. Continue to erase old guidelines that are no longer necessary.

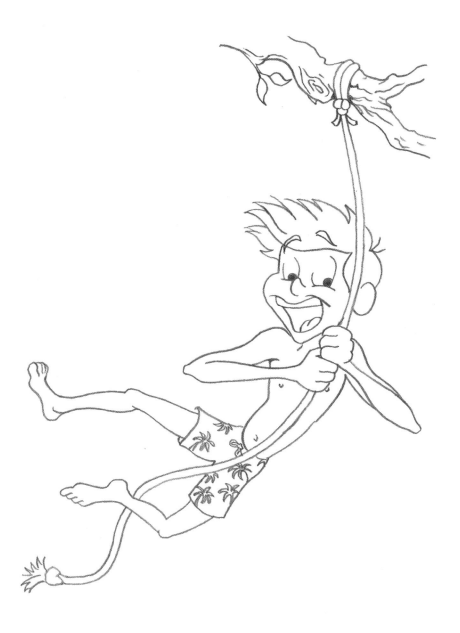

**STEP 5** Give the branch a more woodlike appearance with some knobby bark. Next define the boy's knuckles and break up the hair into wavy clumps. Further define the eyes, mouth, and swim trunks with a few curved lines. Add a few texture lines and some leaves to the branch. Then draw in a fun pattern on the swim trunks.

**STEP 6** Ink the drawing with marker, adding thicker lines for shadow.

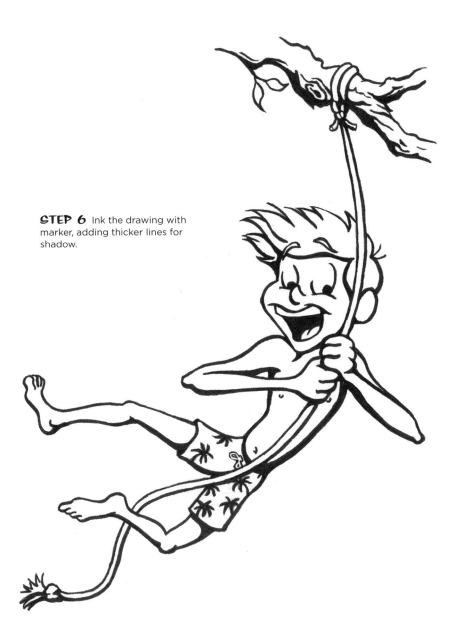

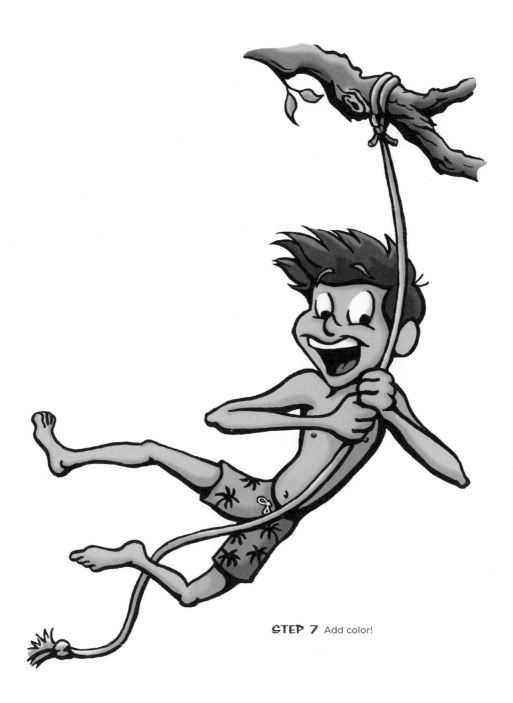

**STEP 7** Add color!

# TEENAGE GIRL

**STEP 1** Start with basic shapes, using a rounded pizza-slice shape for the head, a curved box for the torso, and a pair of odd-looking boomerangs for the legs.

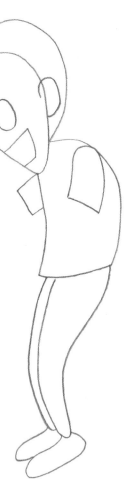

**STEP 2** Block in the eyes, mouth, and ear. Next add a pair of short sleeves and curved rectangular shoes.

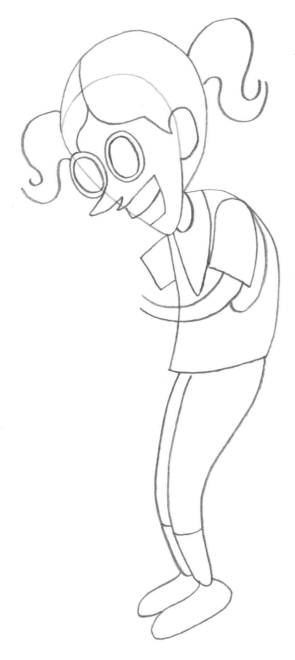

**STEP 3** Draw an upside-down "S" shape for some pigtails and two angles to form her nose and upper lip. Draw another circle around each eye for thick glasses. Next draw a pair of curved lines to define her noodlelike arm.

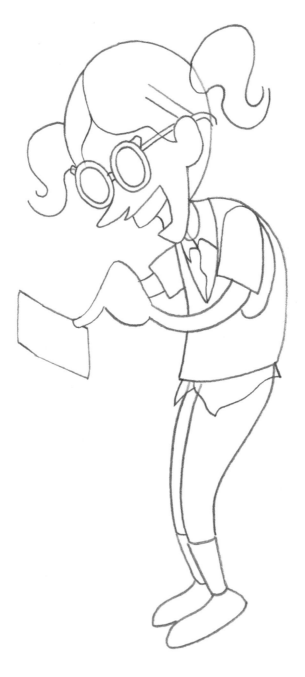

**STEP 4** Add details to her glasses and mouth, and start drawing a pencil behind her ear. Add a collar and a shirttail that sticks out below the vest. Draw an oblong rectangle for a calculator and a shape for a hand.

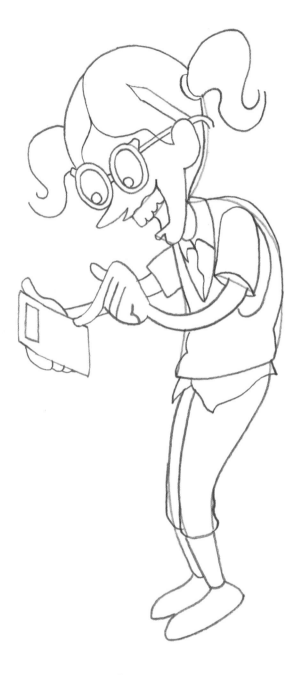

**STEP 5** Continue to build the details.

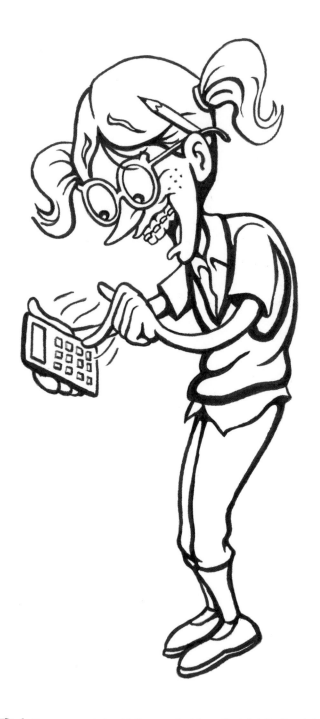

**STEP 6** Erase unneeded guidelines, and add any final details; then ink over the lines.

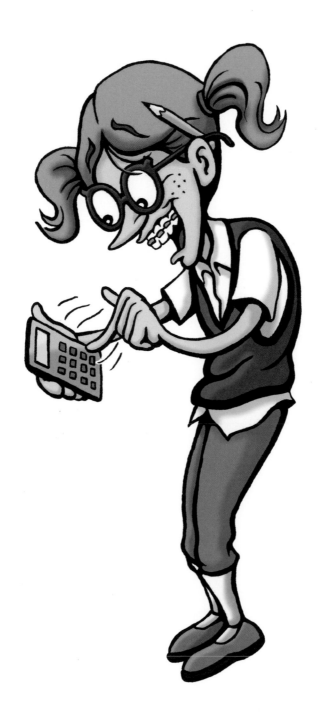

**STEP 7** Add color with markers.

# MODERN WOMAN

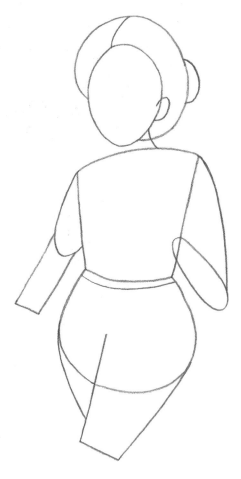

**STEP 1** Start with basic shapes. An egg with a curved line around it is the head. Then draw an upside-down keyhole with a curved, intersecting line for the body.

**STEP 2** Draw a curved lines to indicate a bun, an ear, and a neck. Draw a rectangular shape and a half-oval for the left arm, and an oval and connecting line from the shoulder to mark the right arm. Add a few straight lines to start the legs.

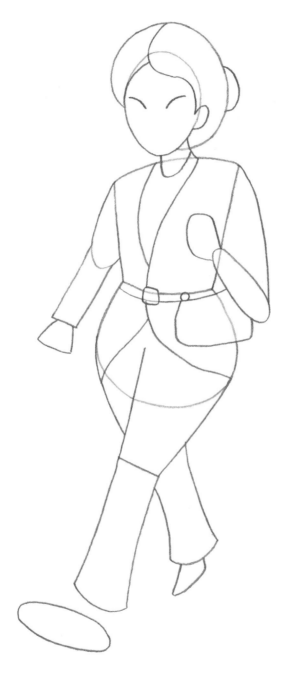

**STEP 3** Complete the cardigan and designate the hands.
Extend the pant legs and mark the feet.

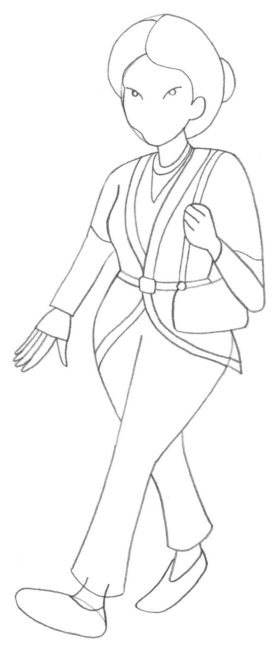

**STEP 4** Start shaping the cheek, hair part, and torso. Add curved lines to mark the sleeves and necklace. Draw long tube shapes for fingers. By the feet, draw a couple of curved lines to form the ankle of the left foot and the shoe on her right.

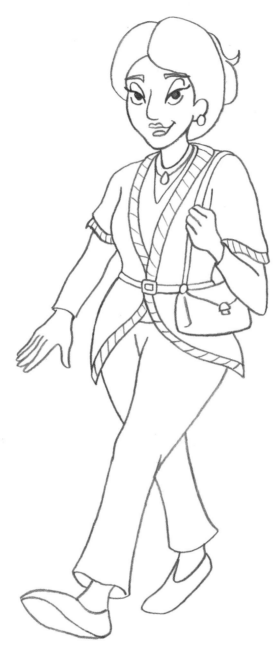

**STEP 5** Continue to build and refine the details.

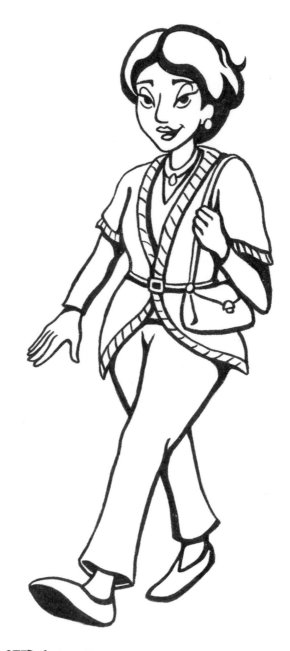

**STEP 6** If you like, ink with a fine-tipped black marker.

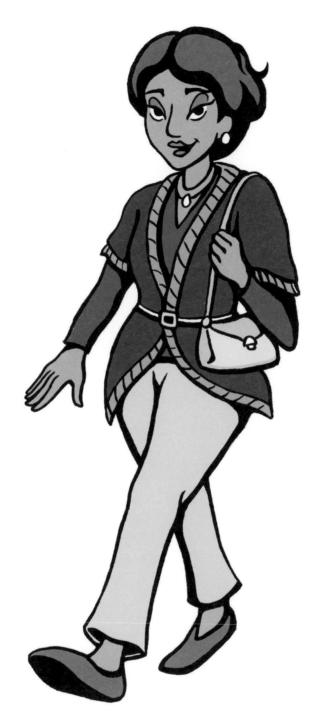

**STEP 7** Add color with markers.

# PRACTICE HERE

# PRACTICE HERE

# PRACTICE HERE

# PRACTICE HERE

# ANIMALS & INANIMATE OBJECTS

**ANIMALS CAN BE VERY EXPRESSIVE.** Cats are known to be aloof, swans are graceful, and eagles and lions are often majestic. We frequently assign human traits to animals, as well. We think of foxes as clever and owls as wise. Our furry and feathery friends have a wide range of emotions and expressions—just like their human counterparts.

**STEP 1** Start with an oval for the bottom of the face and a half oval for the head. Add triangular-shaped ears.

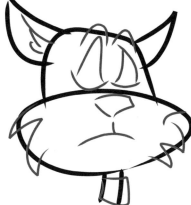

**STEP 2** Add the eyes, nose, mouth, and some tufts of fur on the face.

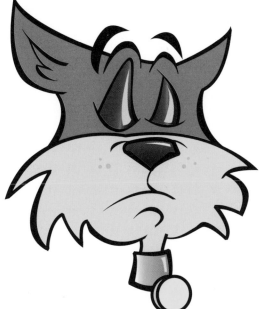

**STEP 3** Finish your feline friend by adding a stubborn chin; thick, raised eyebrows; closed eyelids; and a collar.

**STEP 1** Start with a peanut shape for the body. Add guidelines for the feet, arms, beak, and top hat.

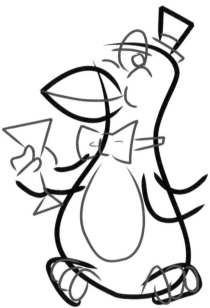

**STEP 2** Add hands and feet, as well as his eye, cheek, and bow tie.

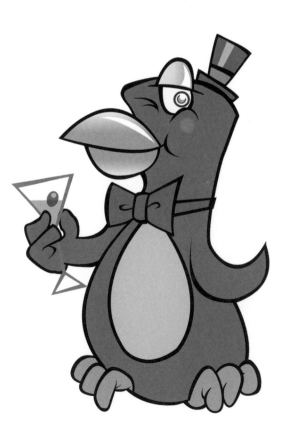

**STEP 3** Shape the beak, and refine the arms and feet.

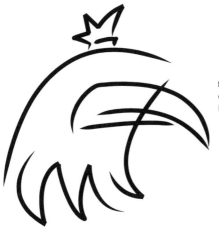

**STEP 1** Sketch the outline of the eagle, adding a long, sharp beak. Draw a small crown on the head.

**STEP 2** Add the eyes and more detail to the crown. Fill in the feathers on the back of the head.

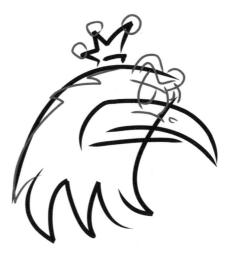

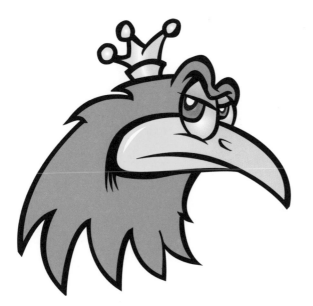

**STEP 3** Erase the lines you don't need; then touch up the beak and eyes.

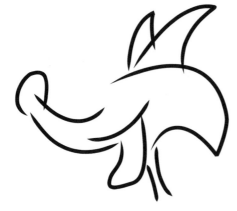

**STEP 1** Draw the basic head shape, open mouth, raised ears, and pointy snout.

**STEP 2** Add the eyes, raised eyebrows, grinning teeth, and more fur around the face.

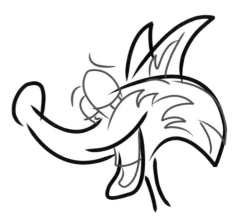

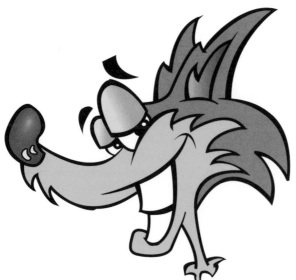

**STEP 3** Finish the details, and add color.

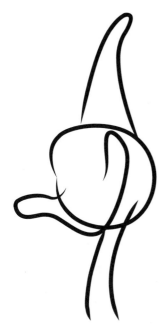

**STEP 1** Draw a circle for the head, and add the outline of the bill, elongated neck, and pointy cap.

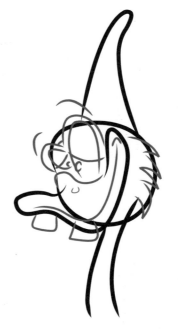

**STEP 2** Add lopsided eyes, buckteeth, and feathers.

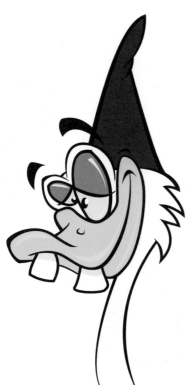

**STEP 3** Fill in the eyebrows and eyelids.

# BREATHING LIFE INTO INANIMATE OBJECTS

In cartooning, anything can be turned into a character—a utensil, a household item, a piece of sports equipment, a mode of transportation. Some objects, such as cars, are practically characters as they are. Other objects, such as toasters, blenders, and mops, require a little creativity. But they all require three things: mobility, personality, and a means of communication.

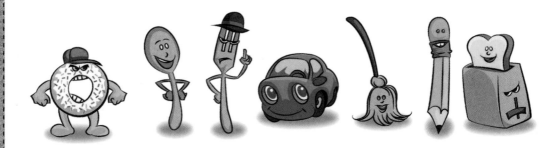

## HOW DO I MOVE?

Almost all characters need to move. Some have innate abilities or structures to exploit, but some need legs and/or arms. So put yourself in the object's place. How would you move if you were a broom? Whatever you choose, always respect the object's uniqueness and inherent qualities.

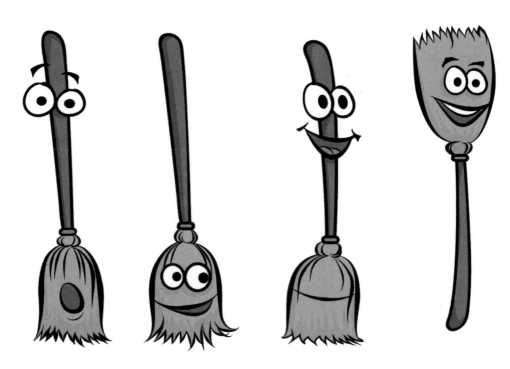

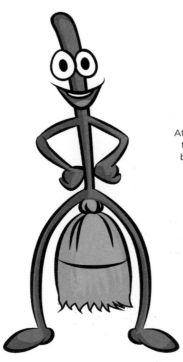

**NO**
Attaching the legs above
the sweeper creates a
bow-legged character.

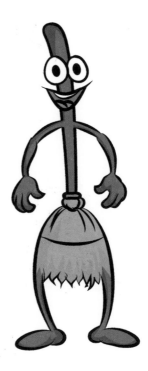

**NO**
Attaching the legs
to the bottom
diminishes the
character's
recognizability
as a broom.

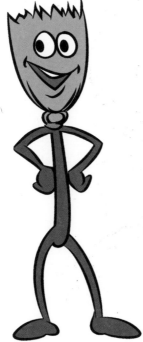

**YES**
Attaching the legs to the
bottom of the handle is
the best choice because it
retains its "broom-ness."

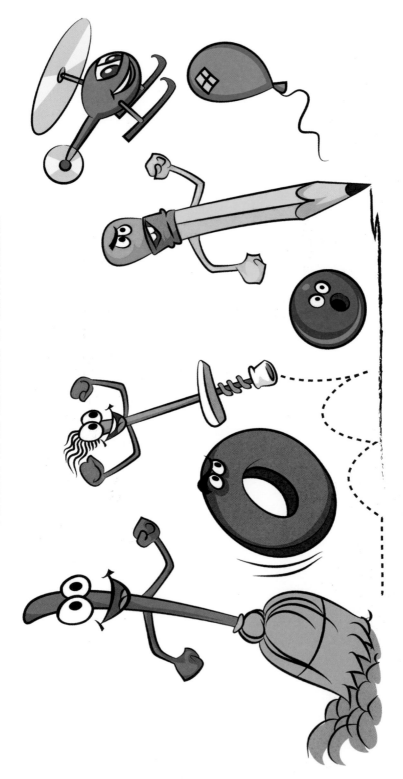

If an object floats, rolls, bounces, wobbles, or rocks, it doesn't need legs, but arms can give it a bit more personality and flexibility. Does a pogo stick need legs? Of course not!

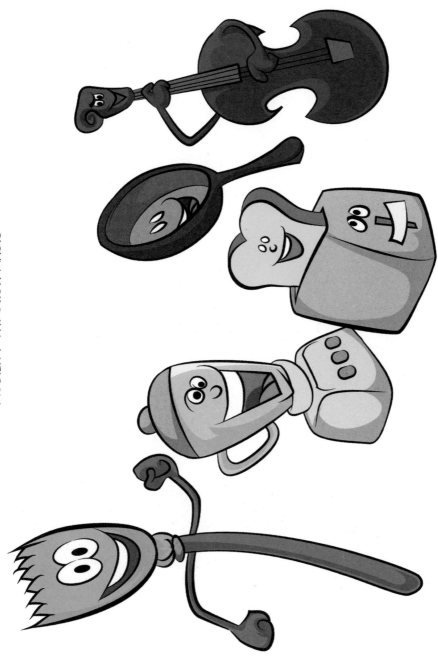

Some objects would be so dramatically altered by the addition of legs that they need some other way to move. If they can't float, roll, bounce, wobble, or rock innately they need magical mobility. So can a frying pan float and wobble around on its handle? You bet!

# THE LAW OF DIMINISHING RETURNS

The more photo-realistic and specific your character, the less relatable it becomes as a 'toon.

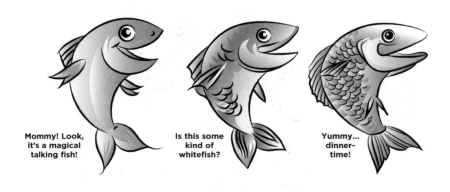

Mommy! Look, it's a magical talking fish!

Is this some kind of whitefish?

Yummy... dinner-time!

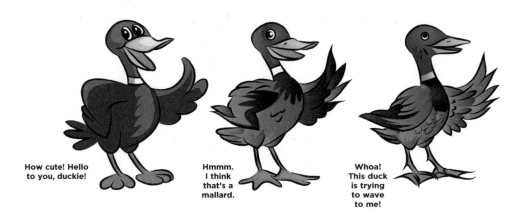

How cute! Hello to you, duckie!

Hmmm. I think that's a mallard.

Whoa! This duck is trying to wave to me!

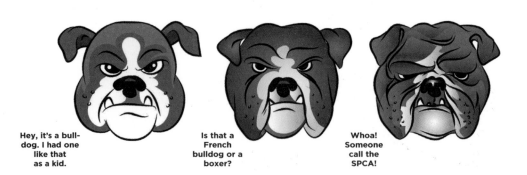

Hey, it's a bull-dog. I had one like that as a kid.

Is that a French bulldog or a boxer?

Whoa! Someone call the SPCA!

**THE MORE REALISTIC, THE LESS UNIVERSAL**

# FROM REAL TO SURREAL

Stylized animals are often the go-to choice for character development. However, if you want to a more serious situation, a less stylized choice would have a more dramatic impact.

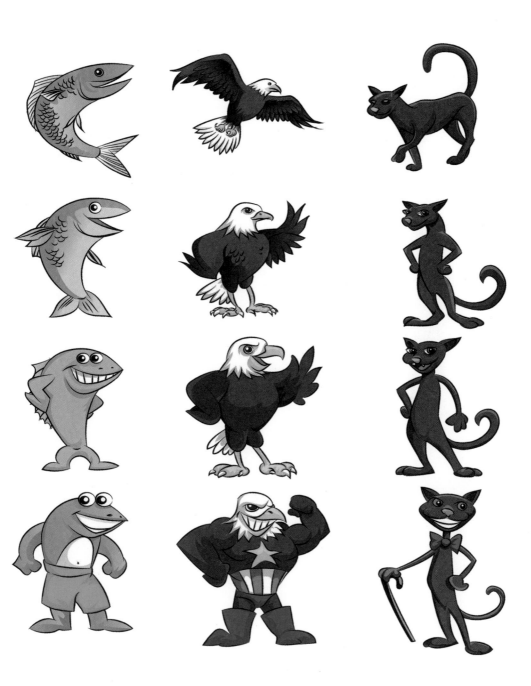

# CARTOON APE

If you can make a stick form ring true and infused with life, the rest is easy.

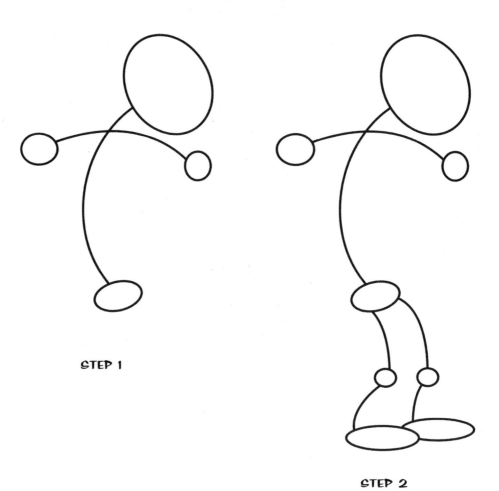

STEP 1

STEP 2

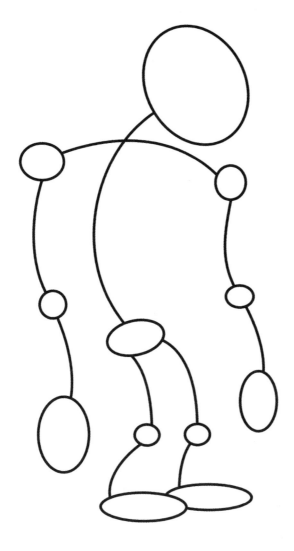

STEP 3

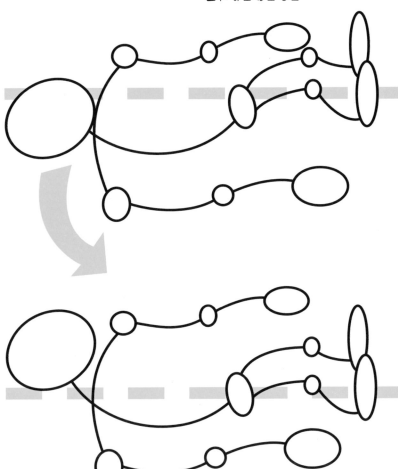

**GRAVITY...IT'S NOT JUST A GOOD IDEA, IT'S THE LAW!**

**I'M CENTERED**
Your character's skeletal structure should be balanced over the center of gravity. This character is stable and at rest. The bones can support the character's weight easily without exerting stress on the muscles to maintain balance.

CENTER OF GRAVITY

CENTER OF GRAVITY

**HELP, I'M FALLING!**
This character's skeletal structure is off-center. The head, shoulders, spine, and hips are too far to the left, making it look like the character is about to fall backward.

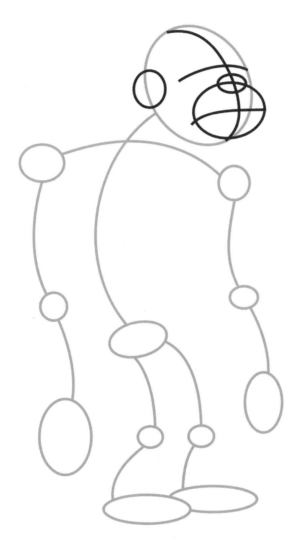

STEP 4

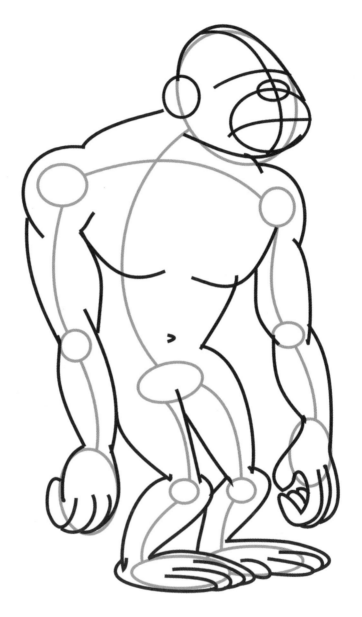

STEP 5

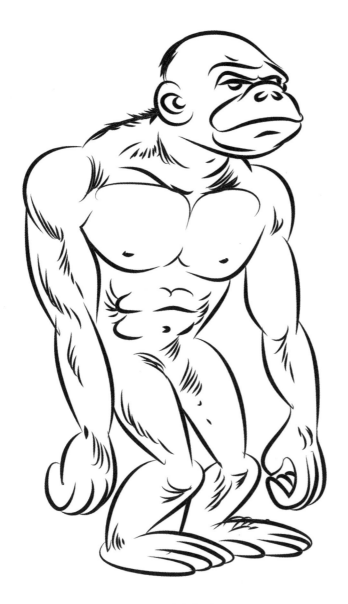

STEP 6

# PRACTICE HERE

# PRACTICE HERE

PART 3

# SCENES & GAGS

# TWO-PANEL GAG

## LIGHT BULB ROLE REVERSAL

Often in a cartoon strip, when an idea pops into a character's mind, a light bulb appears above their head. It's a run-of-the-mill way to illustrate the concept of an idea. But in a cartoon world, inanimate objects can themselves be the characters.

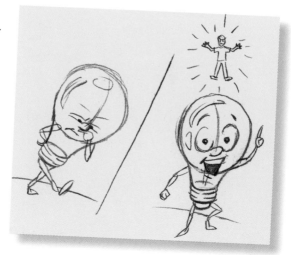

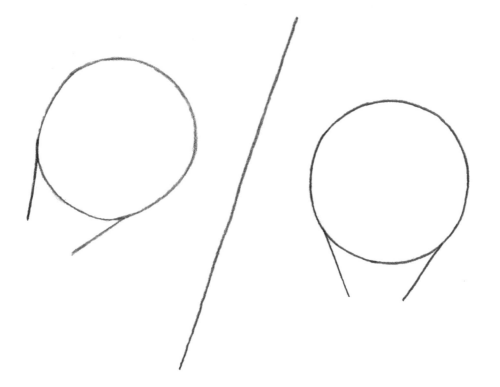

**STEP 1** Divide the paper with a diagonal slash. Then draw a large circle on each side for the light bulb.

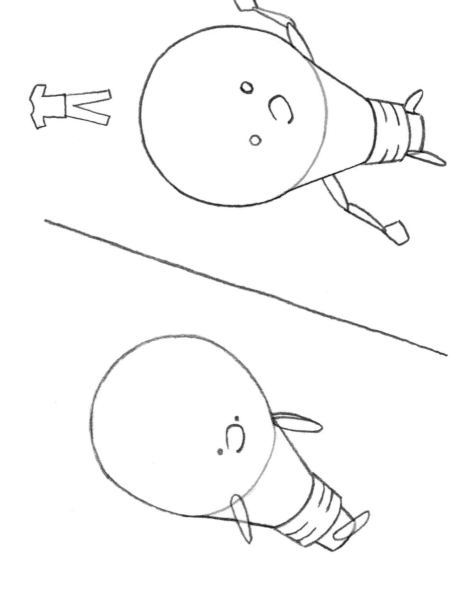

**STEP 2** Add a cup shape for the metal base with curved lines on both bulbs. Add simple oval shapes for the upper arms and small circles for the eyes. Suspended mid-air above the bulb on the right, add a simple shirt and trousers.

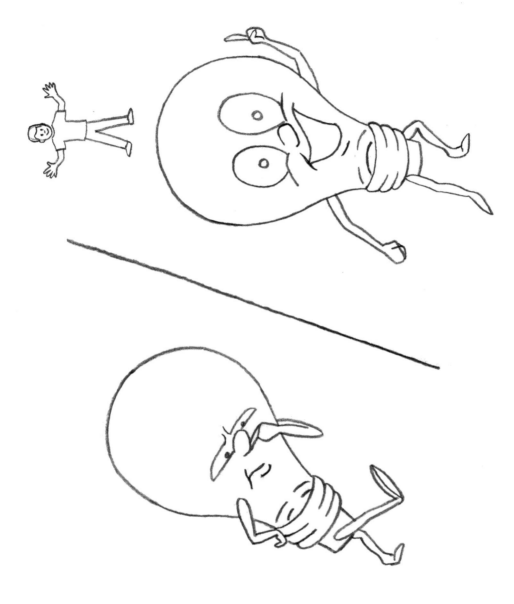

**STEP 3** Finish adding shapes to the legs and arms and erase overlapping lines. On the left, draw a short curved line for the thinking bulb's mouth. On the enlightened bulb, draw a longer curved line for the top of the mouth and a curvy "V" shape for the bottom. Add two bulbous ovals around the pupils for eyes. Add the head, limbs, and a simple face and hairline to the little man above.

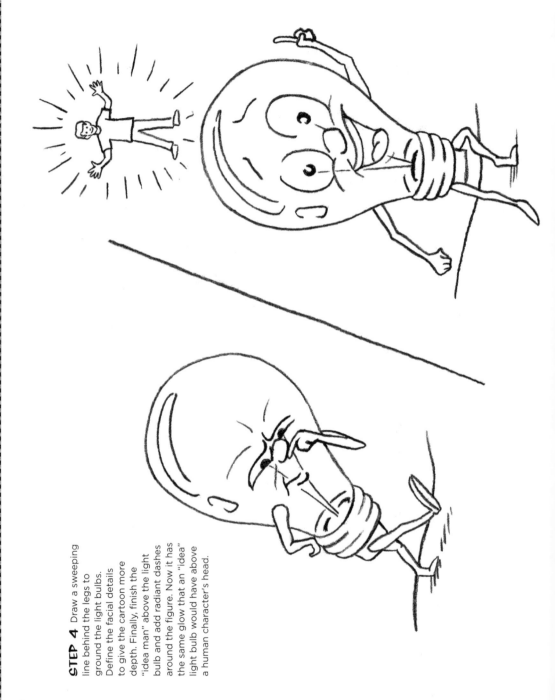

**STEP 4** Draw a sweeping line behind the legs to ground the light bulbs. Define the facial details to give the cartoon more depth. Finally, finish the "idea man" above the light bulb and add radiant dashes around the figure. Now it has the same glow that an "idea" light bulb would have above a human character's head.

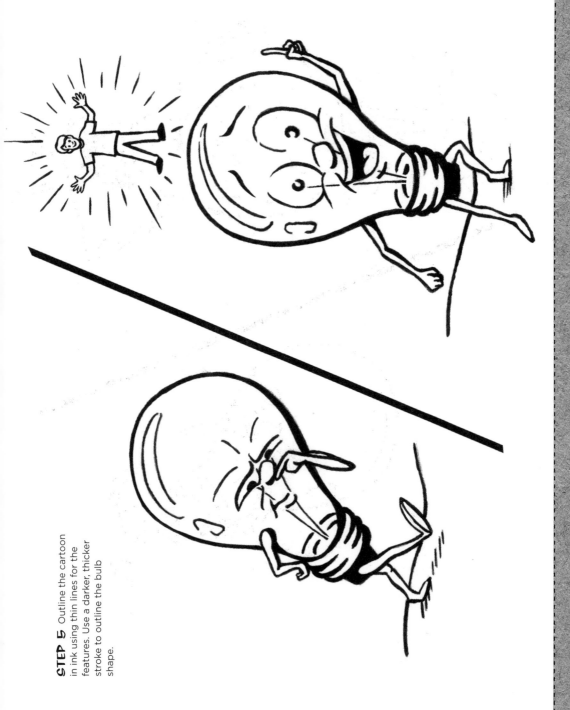

**STEP 5** Outline the cartoon in ink using thin lines for the features. Use a darker, thicker stroke to outline the bulb shape.

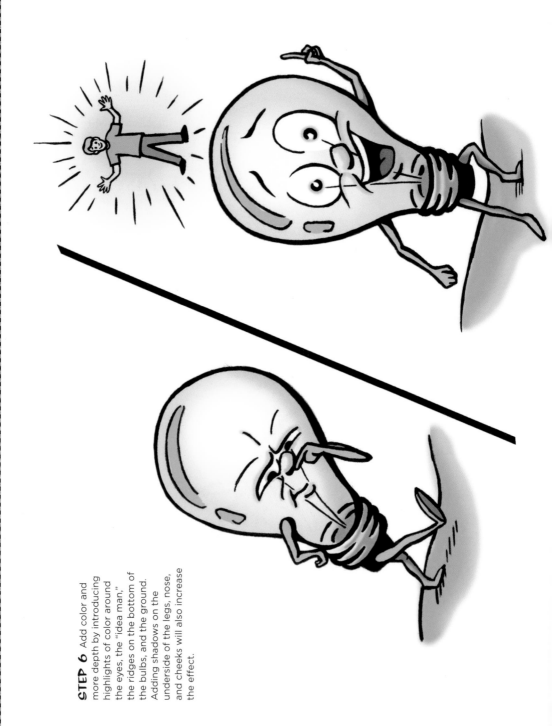

**STEP 6** Add color and more depth by introducing highlights of color around the eyes, the "idea man," the ridges on the bottom of the bulbs, and the ground. Adding shadows on the underside of the legs, nose, and cheeks will also increase the effect.

# PRACTICE HERE

# ONE-PANEL GAG

## FEEDING THE PEOPLE ROLE REVERSAL

The challenge of creating a single-panel cartoon is that you have to convey more information in a single picture.

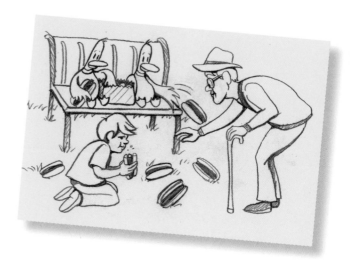

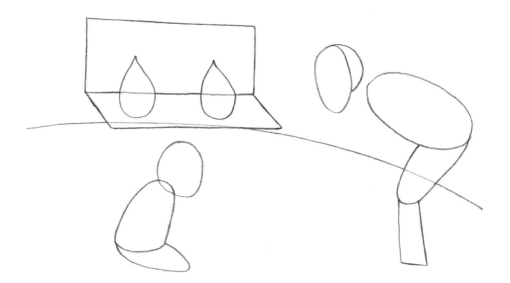

**STEP 1** Draw a curved line for the edge of the lawn; then add a horizontal rectangle above with a slanted seat that stretches from the bottom of the first. Add two large teardrops on the bench for the duck bodies. Begin the boy and the man by drawing simple geometric shapes to map out the heads, torsos, and limbs.

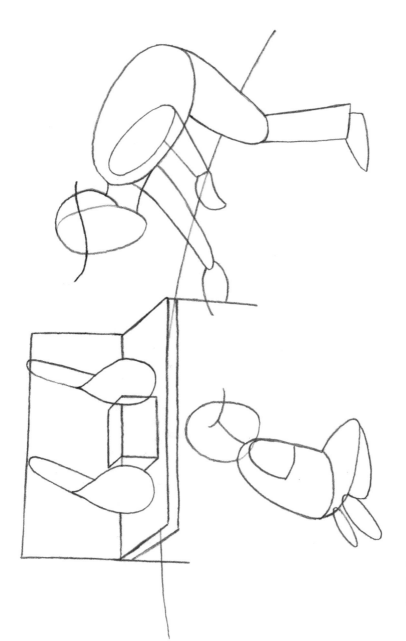

**STEP 2** Add a bottom edge to the bench and two vertical lines stretching from either edge to mark legs. Add elongated shapes on each teardrop for the ducks' heads. Draw a box for the hot dogs. Continue to develop the people.

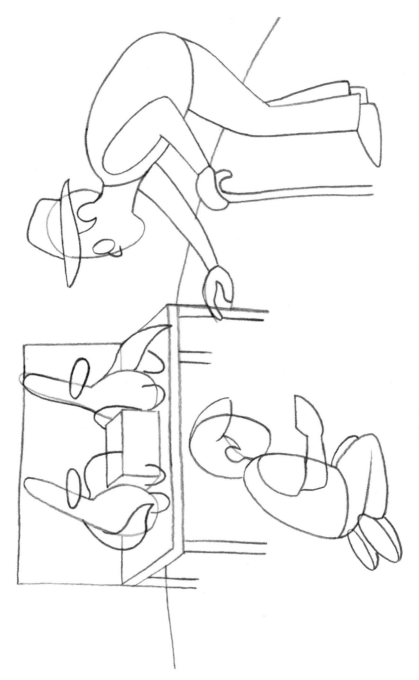

**STEP 3** Continue to draw in the details, building the forms.

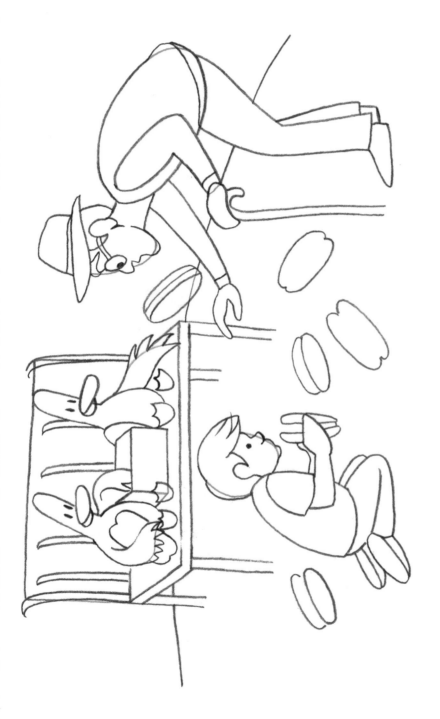

**STEP 4** Define the bench structure. Then draw the eyes for the ducks and hook shapes for their bills and toes. To start on the hot dogs, draw ovals scattered on the grass for the buns. Refine the boy's face by outlining the forehead, nose, puffy cheek, and chin. Refine the hair and add a pupil for the eye. Build the man's face shape and add his pupil, eyebrows, and glasses.

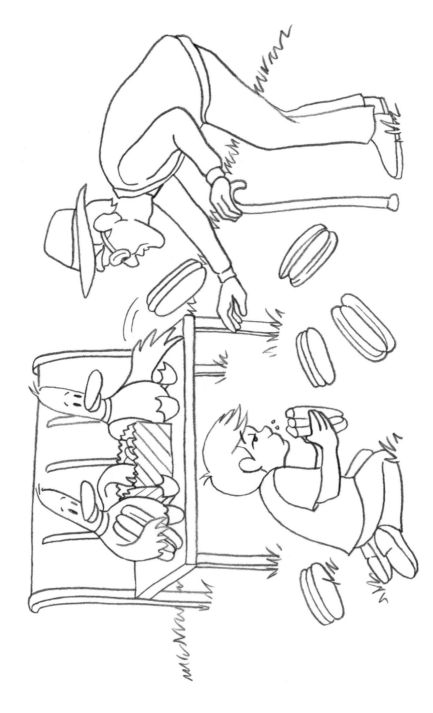

**STEP 5** Erase any unnecessary lines and replace the curved line of the lawn with quick strokes for grass blades. Draw eyebrows, neck bands, and feather tufts on the ducks' heads to give them more personality. Then add long cylinders for the hot dogs. Refine the edges of the characters where needed.

STEP 6 Trace over the lines with a felt-tip pen.

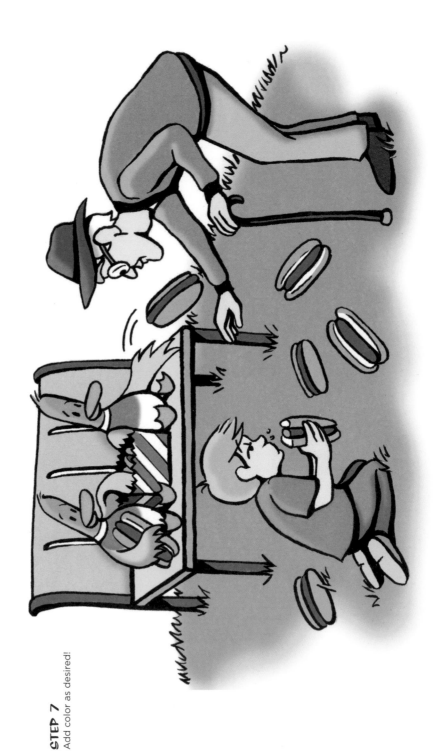

# PRACTICE HERE

PART 4

# CARICATURES

# JUSTIN BIEBER

This teen heartthrob is known for his pouty lips and infamous hairstyles.
Emphasize the hair, lips, and long, angular face.

**STEP 1** Start by sketching
the shape of the cranium,
face, neck, and shoulders.
Draw in the guidelines for the
eyes, nose, and mouth.

**STEP 2** Next place the
large, round eyes, along with
the nose and pouty lips.
Add the ear, jutting jaw, and
rounded chin.

**STEP 3** Sketch in the heavy eyebrows, and define the shapes of the eyes. Refine the shape of the nose, and develop the lips and cheekbone.

**STEP 4** Sketch a tidal wave pompadour on the top of the skull.

**STEP 5** Erase the guidelines from the face and head. Add swooping lines to the pompadour, and work on refining the details in the eyes and nose. Finalize the lines for the neck and shirt.

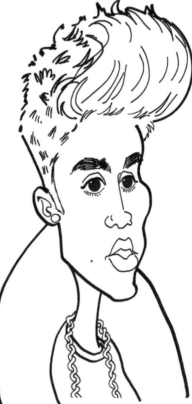

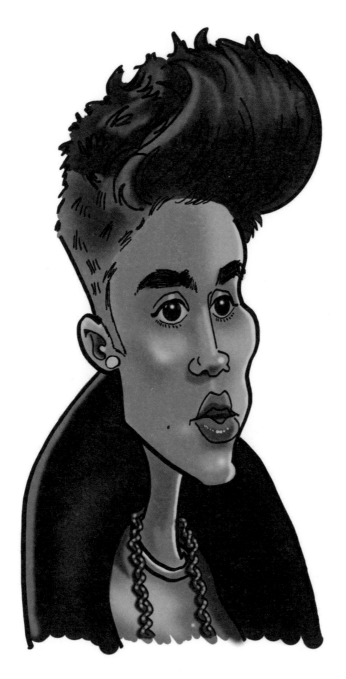

**STEP 6** Add color with markers.

# LADY GAGA

Lady Gaga may be known for her interesting outfits,
but this caricature focuses on her physical features.
Keep her in a simple black dress, glancing over her shoulder.

**STEP 1** Start with a circle for the head, and draw curved lines for the chin. Add curved lines to place the eyes, nose, and mouth. Then draw the body.

**STEP 2** Next add ovals for the eyes and a few simple lines for the nose and mouth.

**STEP 3** Fill in the eyes with large pupils and heavy lashes. Refine the shape of the nose and mouth, separating the lips and teeth.

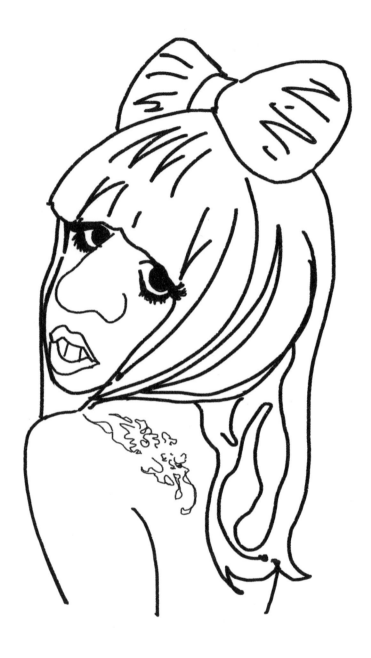

**STEP 4** Next add her hair, with a big bow on top of the head. Draw a tattoo on her left shoulder.

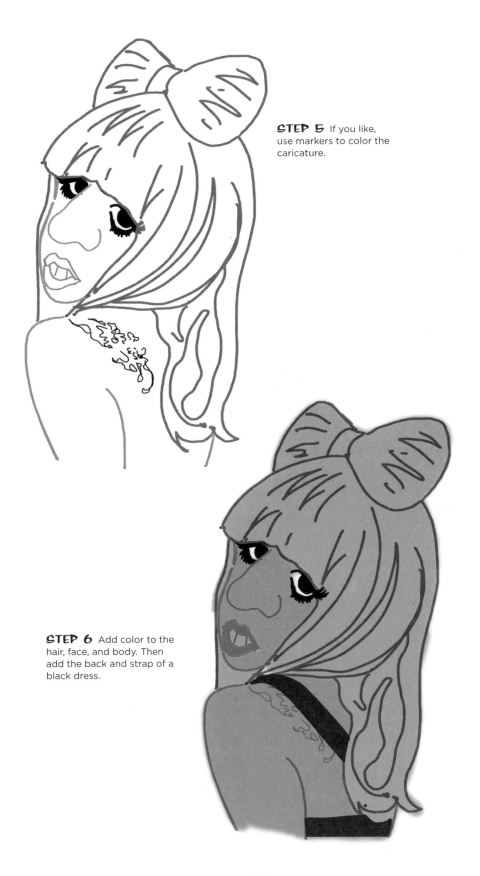

**STEP 5** If you like, use markers to color the caricature.

**STEP 6** Add color to the hair, face, and body. Then add the back and strap of a black dress.

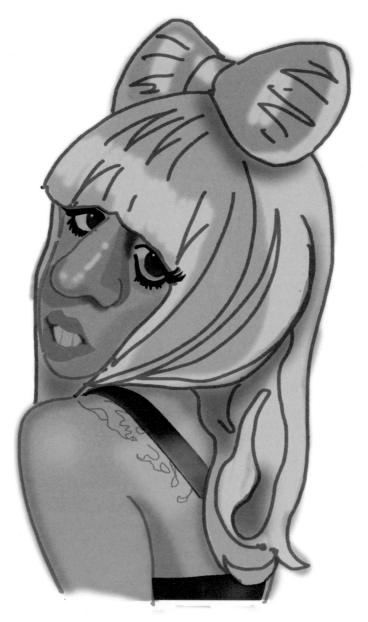

**STEP 7** Next bring in highlights and shadows to give the caricature dimension.

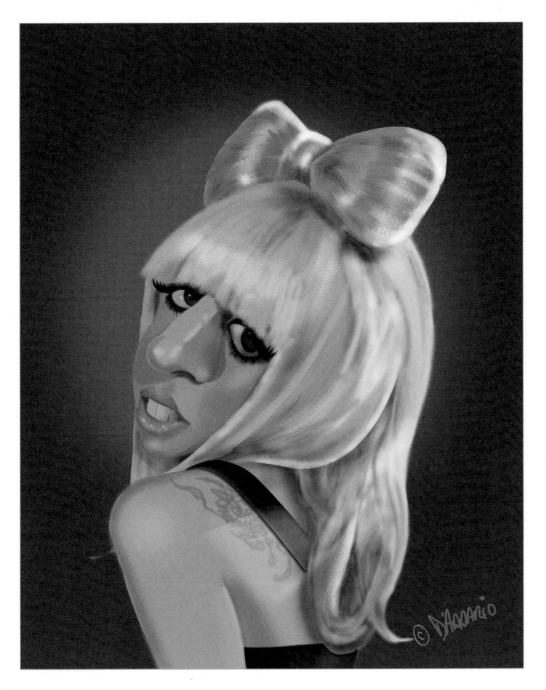

**STEP 8** To finish, add a brown background and some extra highlights.

# ABOUT THE ARTISTS

*MAURY AASENG* has always been excited about drawing and art. After graduating with a BFA in graphic design from the University of Minnesota—Duluth, Maury began an illustration career. His freelance work has spanned a variety of subject matter and illustration styles. An avid nature enthusiast, Maury lives in Duluth, where he supplements his illustration work with wildlife photography and painting. Visit www.mauryillustrates.com.

*CLAY BUTLER* has been working professionally as an illustrator and cartoonist since 1984. His illustration work for *Playboy* magazine and extensive work as a storyboard artist for Discovery Channel, Animal Planet, Disney, and Google further sharpened his theories about how to shape an engaging narrative. Visit www.claytowne.com.

*DAN D'ADDARIO* has been drawing as far back as he can remember. Dan's resume consists of a career spanning almost 30 years as a graphic designer in the automotive field, all while pursuing his passion of caricatures and cartooning. Visit www.dandcaricatures.com.

*JOE OESTERLE* has worked as Art Director for the Teenage Mutant Ninja Turtles apparel division and performed double duty as Art Director and Senior Editor at National Lampoon. His work has appeared in television, radio, books (including *Weird Hollywood* and *Weird California*), magazines, and websites. Visit www.joeartistwriter.com.